PAPER GRAPHICS

GLOUCESTER MASSACHUSETTS

ROCKPORT PUBLISHERS

(more information pg. 192)

CONTENTS

INTRODUCTION

When *The End of Print* was published in 1995, it sent a nervous little shiver through the graphic design world. Although most pooh-poohed the book's dire theories, it nevertheless made many designers feel a tad defensive.

Almost instantly, design conferences were hosting in-your-face, packed-to-the-gills sessions about why print was not ending. Discussions on printed graphics–using paper in more cost-effective, time-efficient, environmentally conscious, design—expanding ways that incidentally produced far fewer paper cuts—sprung up everywhere, in trade pubs, on-line, in classrooms.

Designers responded by literally pushing the envelope–as well as the stationery, business card, presentation folder, packaging, and more. Predicting the death of print–and therefore paper–was heresy, and they were damn well going to prove it.

Of course, predictions of the paperless society—most of which were distributed to the world on paper—ironically have turned out to be unfounded, much to the relief of graphic designers for whom paper is as much an element of the natural world as water, fire, earth, and air. Purely electronic, nonprinted design has pushed on its merry way, developing almost into an entirely different strain of work, related to but decisively separate from print graphics.

But the book's warning volley caused many designers to reexamine paper, a tool they had long taken for granted as a simple carrier. The situation compares favorably to the story of the man who grieves the loss of a hand, not because of the injury itself, but because he now realizes that the fingers and thumb he previously had used for mundane tasks like raising food to his mouth could also have been used to play the cello, to paint portraits, and a million other wonderful things. The difference for designers is that they got a second chance to examine their hand, so to speak.

And so began a paper renaissance of sorts, with paper manufacturers and printers cheerfully getting into the act. What designers could imagine, they could and would produce. A taut creative circle developed: When designers clamored for improved selection, manufacturers responded with hundreds of new varieties. Printers learned to deal with the new products. Spurred on by printing successes and the beautiful papers, designers continued to create even more incredible graphics on paper. Manufacturers fine-tune their offerings with more color, more weights, and on and on the cycle spins.

This book, as a result, could have been much longer. It is not a historical compilation—some extremely noteworthy designs from the past will not be found here. Instead, it is a snapshot of a particularly paper-creative point in time.

The work shown in the book can be divided into three main sections: papers that are used for conceptual, aesthetic, or performance reasons.

• Conceptual designs trade off on common conventions: A report for CFOs is designed into the very familiar shape of the *Wall Street Journal*. Even a sheet's content can underline designers' messages: For instance tree-free stock can be specified for an environmentally conscious project.

• Aesthetic pieces delight the eyes with color, the fingers with their tactile nature, or even the nose with their smell. Witness the golf-course brochure shown later in this book, printed on paper made from golf course cuttings, a sheet that is reputed to smell like fresh-mown grass when subjected to the heat of a laser printer.

• When a designer plans to emboss, die-cut, fold, thermograph, letterpress, engrave, or otherwise abuse paper, performance is a huge concern. The sheet has to be beautiful yet tough enough to take it.

In its gloomy (or was it gleeful?) prediction of doom, *The End of Print* inadvertently gave printed graphics—paper graphics—the boost it did not know it needed. Today, the thinking, truly creative designer realizes that paper is much more than a simple carrier for information:

It is a part of the message. Like the elements of the natural world, paper must be used wisely

to be effective. It is as precious as the earth from which its ingredients are grown, as well as

the water, fire, and air that helped to form it.

—Catharine Fishel

FUNCTIONAL PAPER

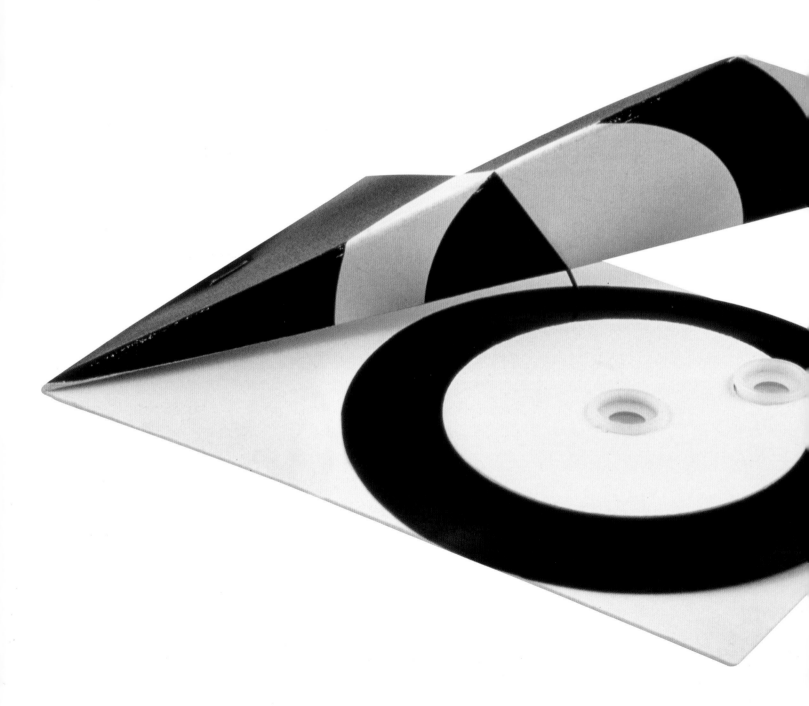

A box for Chinese takeout. A carefully folded airplane. A lamp-shade glowing on a rainy night. Each is an everyday example of paper that functions.

The ability to transform a piece of paper from something that lays lifelessly on the table into a functional object requires a special kind of ingenuity. Designers seem to consider it their personal challenge to fold, cut, fasten, and in general abuse paper until it does things it never was intended to do.

Witness Stefan Sagmeister's paper record player or Henderson Tyner's mirror-like annual report, featured in this section. Each changes paper from a carrier of information into the message itself. It is a genuinely magical feat.

Designers know better than anyone that paper is the perfect building material. It is light-weight yet strong, inexpensive enough to be accessible, and infinitely flexible in terms of color, size, texture, and weight. Fortunately or unfortunately, paper is also ubiquitous enough to be disposable. A functional object made from paper can serve its purpose and be discarded to make room for newer, more innovative designs.

In a world that measures speed in bits per second, the type of work featured in this section is successful because it causes the viewer to pause. A recipient cannot help but get involved with the message. In fact, sometimes he cannot even bring himself to throw the piece away: It is too much like a gift.

Sagmeister, Inc. Paper record player mailer (p. 13)
Paper: Chipboard

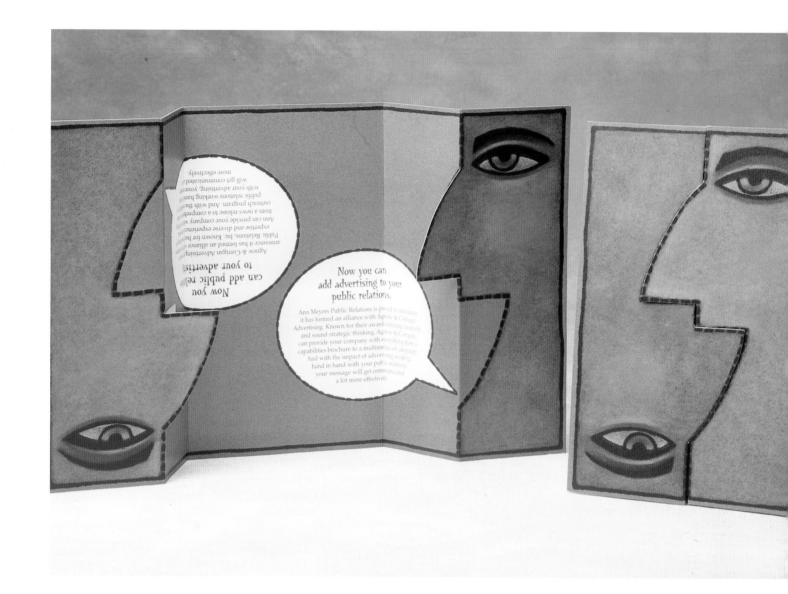

DESIGN FIRM Agnew & Corrigan Advertising

ART DIRECTOR Julie Schmidt

DESIGNER Michael Douglas

ILLUSTRATOR Phillip Dvorak

COPYWRITER Ward Latshaw

PRINTER White Oak Printing

PAPER Proterra Flecks Oyster Cover, 80 lb.

Agnew & Corrigan face-to-face promo This self-promotion—announcing that an advertising agency

and public relations firm were joining forces—began life as a flat image in a stock illustration book.

Separating the faces brought the art to life. When the piece is closed, it looks just like the original art:

The faces latch together and enclose the mailer's message. When it is opened, the noses fall back into

the newly added background/message area from which they are die-cut, and the work lies flat.

Henderson Tyner Art Company **DESIGN FIRM**
Troy Tyner, Hayes Henderson **ART DIRECTORS**
Doug Grindstaff, Amanda Love, Troy Tyner **DESIGNERS**
Hutchison Algood Printing **PRINTER**
Wyndstone Mylar **PAPER**

Henderson Tyner mirror book The Cone Denim trend book, which forecasts trends in denim specifi-

cally and culture in general, is all about image. The designer of this piece, Henderson Tyner Art Company,

felt that a reflective cover would not only grab attention, it would also allow the reader to see him— or

her— self as part of the action. White type creates the shape of a head on the reflective mylar; the

reader provides the visual, his or her own face.

Sagmeister Inc. sundial mailer | A walk in the park inspired this unusual self-promotional piece for Stefan Sagmeister. After admiring a stone sundial, he decided to make his own desktop-sized version. When his composition turned out to be the size of a postcard, he could see its potential as a mailer. Uncoated vellum glued to chipboard provides stability for the piece, which is accurate within five minutes anywhere in the United States. Recipients loved it: Sagmeister still sees his sundial taped to desks in offices he visits.

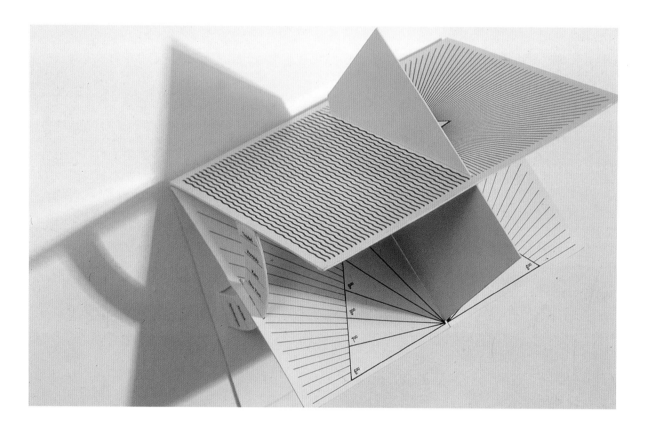

DESIGN FIRM Sagmeister, Inc.
DESIGN Stephan Sagmeister and Veronica Oh
PAPER Chipboard

Sagmeister Inc. paper record player mailer After creating a paper record player as a holiday mailer for a music-industry recording client, Stefan Sagmeister created one for his own office, too. A children's physics book provided the model and the basic mechanics for the contraption. The self-promotion mails flat and is assembled by the recipient. Sagmeister's spoken promotional message was recorded on a plastic disk, and a needle—actually, a straight pin—plus a cardboard speaker delivers the sound as the disk is turned by hand.

DESIGN FIRM Vrontikis Design Office
ART DIRECTOR Vrontikis Design Office Staff
PAPER Fox River Confetti

Vrontikis Design Office gift tags | Vrontikis Design Office piggybacks gift tags onto the edges of clients' jobs (with permission) throughout the year, making use of trim that would normally be thrown away. Tag designs are done ahead of time, when VDO designers have downtime. That way, when an opportunity to "tag along" presents itself, the piece is ready to go on press. By year's end, the office has a beautiful holiday gift package for clients and friends.

Louey/Rubino Design Group **DESIGN FIRM**
Robert Louey **DESIGN**
Lithographix, Inc. **PRINTER**
Hopper Cardigan. **PAPER**

Louey/Rubino Design Group grommeted calendar "Connections" is one in a series of five promotional calendars Louey/Rubino Design Group produced for a printer and various paper companies. The designers' goal was to graphically show that all people are connected, not only by geography, but by history, art, and culture as well. By creating we connect, principal Robert Louey believes. Usually commonplace paper grommets function as physical as well as metaphorical connectors, joining one point to another while suggesting motion or direction.

Peter Felder 123 Plakate box For an exhibition of the poster work of 23 Austrian graphic designers, Peter

Felder of Peter Felder Grafikdesign created a different kind of exhibition catalog: a black paper box that

contains 23 postcards, each a sample of the featured artists' work. This is a more memorable presentation

than the standard, book-like catalog. An elasticized cord holds the package shut, positioned at an unusual

angle that mimics the box's printed design.

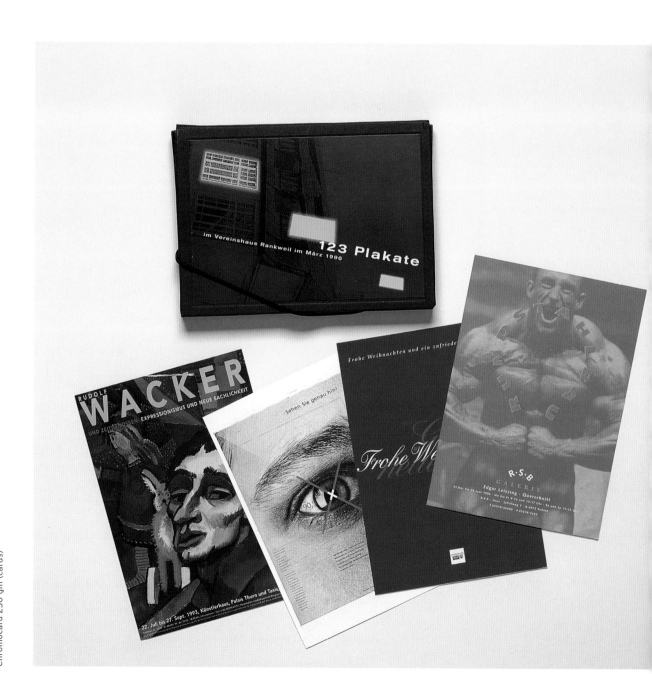

DESIGN FIRM Peter Felder Grafikdesign
DESIGNERS Peter Felder, Bené Dalpra,
Kurt Kornig
COPYWRITER Lars Müller
PHOTOGRAPHER Harald Peter
PAPER Zöchling Black/Black 480 gm (box);
Chromocard 250 gm (cards)

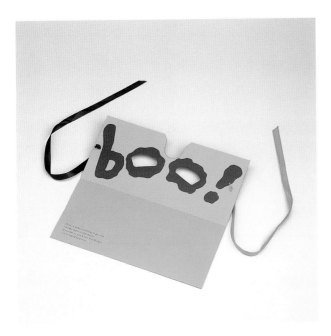

Bull Rodger **DESIGN FIRM**
Steve Lloyd **DESIGNER**
Paul Rodger **COPYWRITER**
GF Smith Colourplan Mandarin 270 gsm **PAPER**

Bull Rodger Halloween card | A simple die-cut turns this Bull Rodger Halloween card into a functioning mask that its recipient can wear to celebrate the holiday. The design is perfed at the fold to make separating the card's halves simple. Inside, the eyeholes become part of the typography, and a small promotional message reminds the wearer of the source of the mailer.

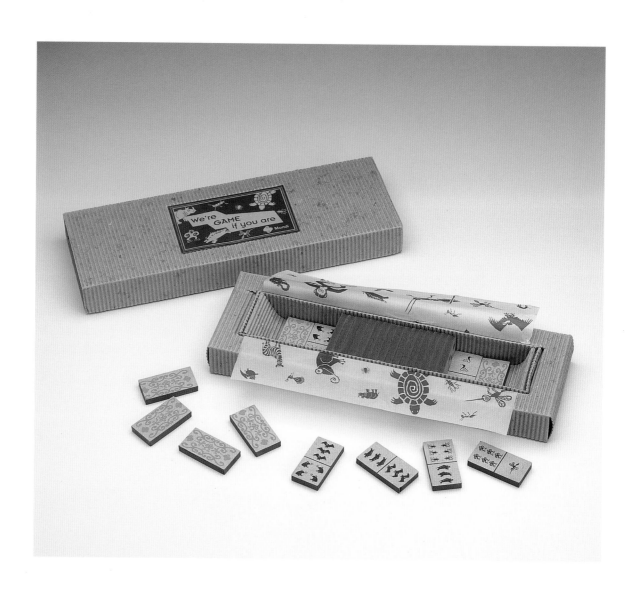

DESIGN FIRM Cross Colours Ink
CREATIVE DIRECTORS Joanina Pastoll, Janine Rech
DESIGNER Joanina Pastoll
PAPER Various Mondi products

Cross Colours Mondi dominoes "We're game if you are" is the title of this game/invitation made entirely from paper. The mailer's box, invitation card, and centerpiece—a set of dominoes—all are made from the client's paper products. The barbecue was held on a game farm, so all of the dominoes use animal images.

Lippa Pearce Design Limited **DESIGN FIRM**
Rachel Dinnis **DESIGNER**
Terracotta Press **PRINTER**
Carousel, Hunter 100 gsm **PAPER**

Lippa Pearce bookplates Think of the design of a bookplate and most people visualize a very traditional look. Rachel Dinnis, the Lippa Pearce Design associate who created this set of bookplates, decided instead to make them more contemporary. She looked at other ways in which we express ownership of objects and people in our lives—license plates, tattoos, animal tags, monogramming, and so on—and used photos to illustrate them, another contemporary medium. Packaged in two plastic sleeves with a slipsheet, she originally sent the twenty-four piece set as a gift for clients, but it may also be retailed as a charitable fundraiser in the future.

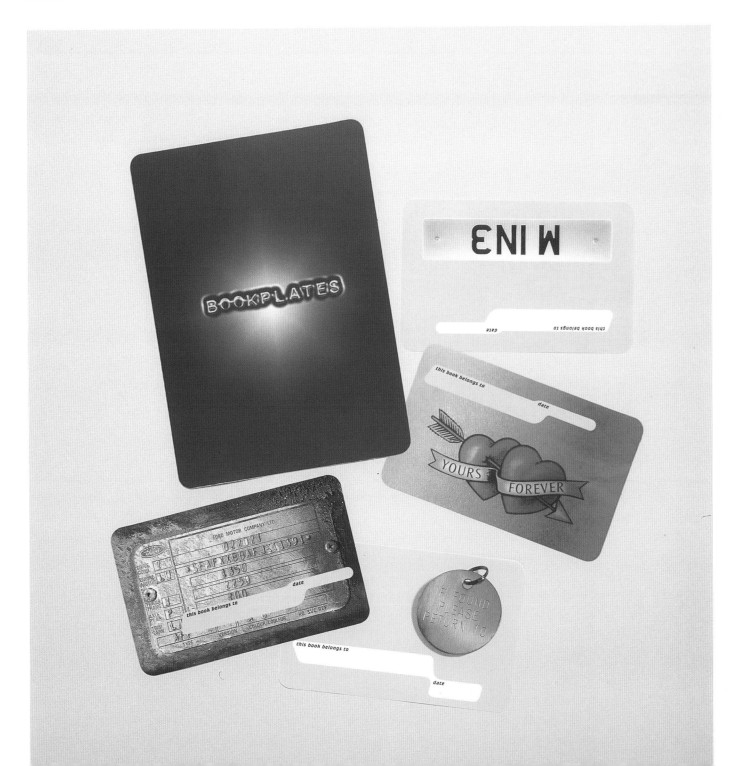

Susan Skarsgard holiday ornament Designer and letterer Susan Skarsgard, printer Wesley B. Tanner, and papermakers Kathryn and Howard Clark collaborated to create this unique holiday ornament. The concept for the tactile, dimensional piece occurred spontaneously between the four individuals when they set out to create something that would delight friends at the end of the year. Handmade paper, printed letterpress, and then hand painting and assembly make a memorable mailer.

DESIGN FIRM Susan Skarsgard
PRINTER Wesley B. Tanner
PAPER Handmade by Twinrocker Paper Mill

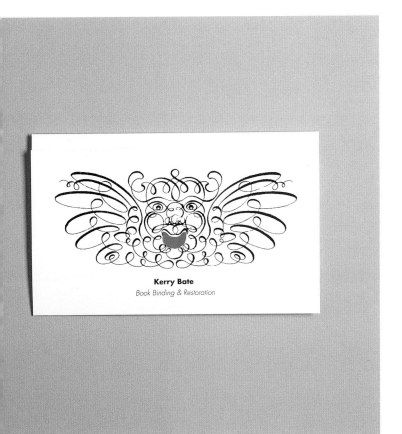

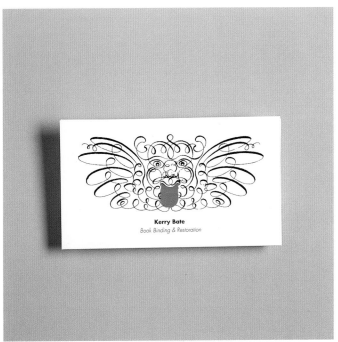

George Tscherny book restorer business card | Kerry Bate binds and restores antiquarian and contemporary books. Similarly, Bate practices this very traditional profession today. Designer George Tscherny wanted to project that range of time in his design for Bate's new business card. His solution is a squeezable, oversized card that carries the image of a very traditional face within a flourish. His contemporary twist: When the card's top and bottom are squeezed together, the character sticks out his tongue through a die-cut slit.

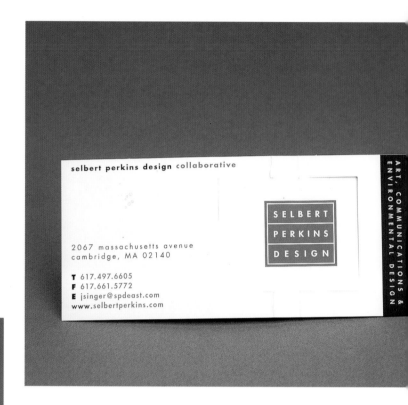

selbert perkins design collaborative

ART, COMMUNICATIONS & ENVIRONMENTAL DESIGN

SELBERT
PERKINS
DESIGN

2067 massachusetts avenue
cambridge, MA 02140

T 617.497.6605
F 617.661.5772
E jsinger@spdeast.com
www.selbertperkins.com

DESIGN FIRM Selbert Perkins
DESIGNER Clifford Selbert
PAPER S.D. Warren 100 lb. Strobe coated dull

Selbert Perkins business card　Selbert Perkins Design's business card was made interactive—the center panel flips back and forth as the card is opened and closed—to communicate the office's three-dimensional offerings (environmental communications, landscape architecture, and more) through a printed application. Principal Clifford Selbert feels that such interactive elements provide a distinctive visual identity and increase the recipient's involvement with, and recall of, the piece.

blackcoffee design **DESIGN FIRM**
Laura Savard, Mark Gallagher **DESIGNERS**
Printer's house stock, coated 80 lb. cover **PAPER**

FUNCTIONAL PAPER 23

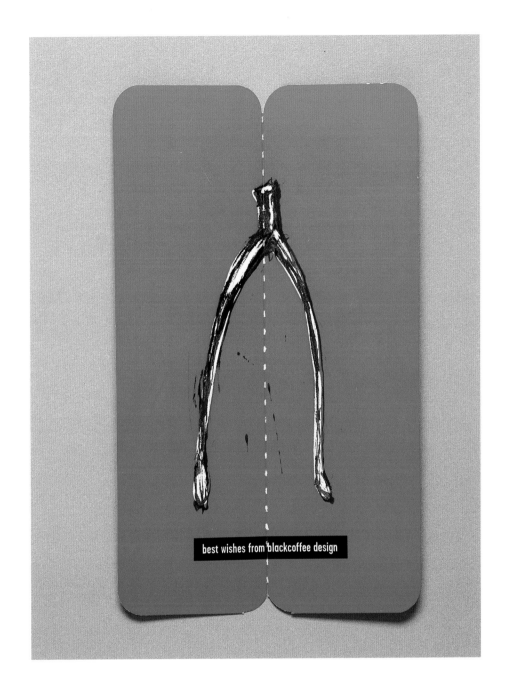

blackcoffee wishbone greeting The firm blackcoffee design sends out at least six promos every year, each usually centered around a holiday. The frequency of its self-promotional program forces the firm to keep its costs down. This Thanksgiving mailing is an excellent example. Recipients instantly understand the simple wishbone motif: A perf down the middle allows them to actually split the piece. The design firm paid only for mailing because the piece was piggybacked onto another job.

blackcoffee AIGA sticky label invitation | Because each Boston AIGA meeting was held at a different location, members had trouble identifying each other once they arrived. A name badge would help the problem. When blackcoffee design took on the assignment to design an invitation to yet another meeting, its designers decided that the logical and least-expensive route would be to make the mailer itself a name tag. The solution, though the ink took three days to dry: printing on the back of the peel-off backing.

AIGA
69 west newton st.
boston ma 02118
hotline 617.446.9082
national 800.548.1634

aiga

presort
non-profit organization
third class postage
us postage paid
boston ma
permit no. 51504

place label here

paper-strathmore-writing label stock-ice blue
printing-fleming printing-somerville
design-blackcoffee design-boston
illustration-mark a gallagher

get2gather #9
march 29th
6:30 pm at
regolia
480 columbus
ave boston
617 236 5252
this AIGA boston
propaganda
should serve to
identify you
as an AIGA
member. so stick
it to the body
part of your
choice and let
everyone know
you're a proud
member of AIGA
boston !

DESIGN FIRM blackcoffee design
DESIGNERS Mark Gallagher, Laura Savard
ILLUSTRATOR Mark Gallagher
PAPER Strathmore Writing Label in Ice Blue

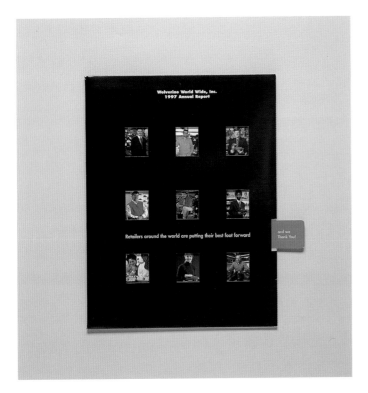

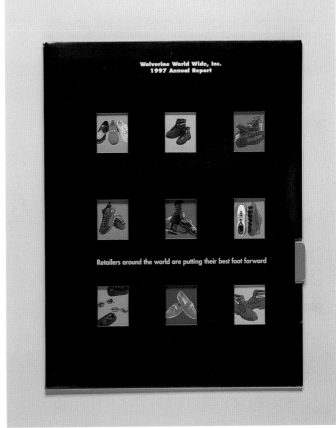

Pangborn Design Wolverine annual report Pangborn Design created this Wolverine World Wide annual

report as a visually enticing expression of the company's message: the transformation from product to sales.

The cover is actually two covers: A sliding insert reveals different photos. Principal Dominic Pangborn says that

many other designers have tried this approach, but his design succeeds from a practical standpoint because

its fold was carefully engineered to prevent jamming on the press.

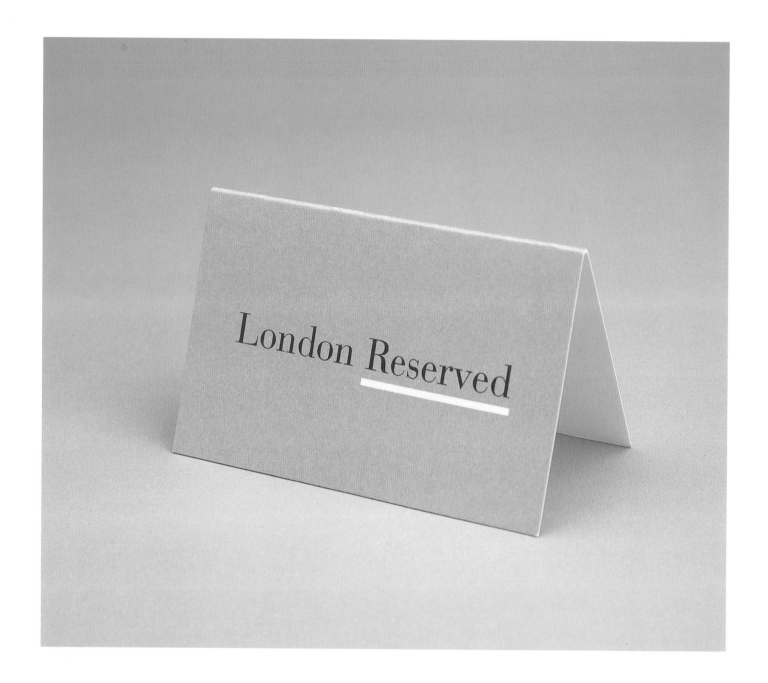

DESIGN FIRM @KA
DESIGNER Albert Kueh
PAPER Ivorex

@KA London Reserved business card London Reserved is a company that specializes in booking events for its clients. In need of a business card, it contacted Albert Kueh at @KA in London. After considering more traditionally shaped cards, Kueh finally decided to reinforce his client's specialty by creating a "Reserved" card. The finished piece looks very much like a card one would find on the table of a finer restaurant.

@KA Eat Drink Man Woman promo @KA's promo for the film *Eat Drink Man Woman* must literally be torn into in order to enjoy it, just as a good meal must be consumed in order to be appreciated (food is a primary feature of the film). Page edges are closed (untrimmed): To see the photographs inside, the pages must be torn apart. Designer Albert Kueh says he hid the visuals so that each brochure would be unique when torn, in the same way a dish would taste different to every person. Consonant with the food theme, the design's wrapping is a grease-proof paper used for baking.

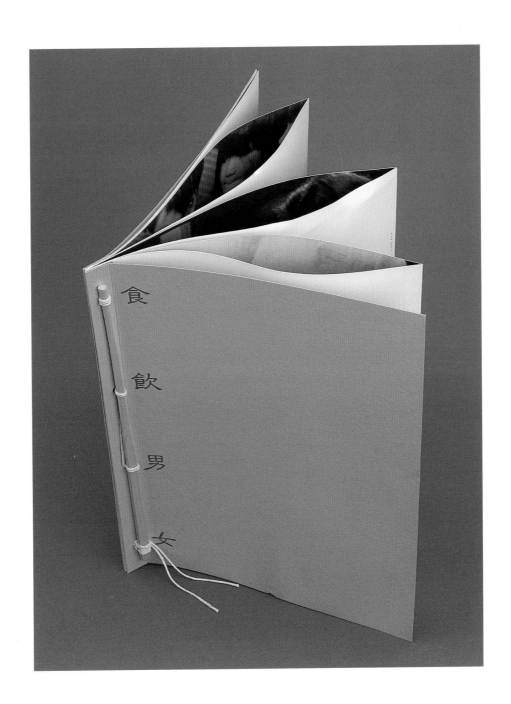

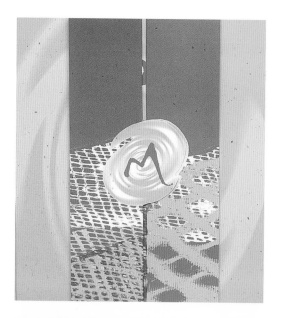

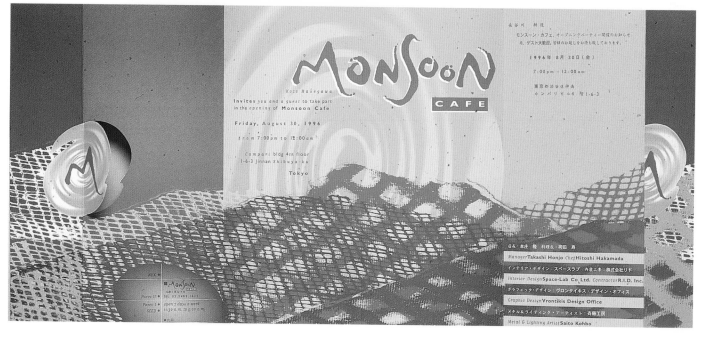

Vrontikis Design Monsoon Cafe invite When it lands in the hands of a recipient, this invitation, created by Vrontikis Design Office for the Monsoon Cafe, appears to be a quiet trifold brochure. But when opened, the design quickly begins to make noise: Bright colors and exciting textures are revealed, together with a clever die-cut clasp. Principal Petrula Vrontikis says the idea for the clasp and repeating folds came from the need to express integration in an innovative way. The client wanted to create an invitation that reflected the brightness, excitement, and innovation of its Asian eclectic restaurant: Vrontikis' solution accomplishes that.

Thomas Manss Christmas card | The Thomas Manss & Company Christmas card features the essential accessory for the holidays: a die-cut Santa beard with a simple season's greetings message. The beard can be pressed out and used as a disguise at the inevitable Christmas parties, says principal Thomas Manss. The texture of the paper evokes the hairy nature of the subject.

116 Regent's Park Road...London NW1 8UG...0171 722 3186

What the well-dressed are wearing this season

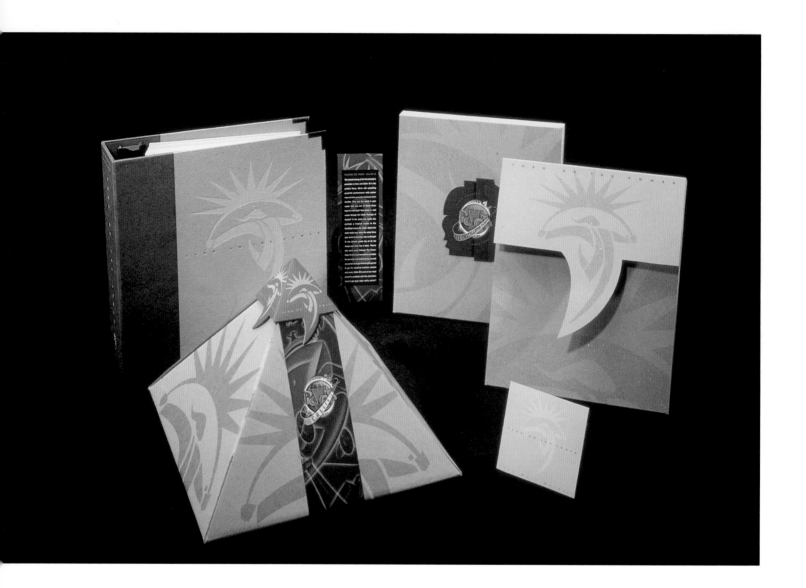

30 PAPER GRAPHICS

DESIGN FIRM Vaughn Wedeen Creative
ART DIRECTOR Steve Wedeen
DESIGNERS Steve Wedeen, Adabel Kaskiewicz
COMPUTER PRODUCTION Matt Golden
PRINTER Monarch Business Forms
PAPER E-flute kraft cardboard laminated on one side to expose E-flute kraft cardboard

Vaughn Weeden pyramid Having packed its client's sales-incentive programs in uniquely shaped containers for the previous two years— round mailing tubes and square boxes— designers at Vaughn Wedeen Creative felt that a pyramid or triangle was a natural geometric progression. The pyramid is also widely recognized as a symbol and source of power, which made it a good match for US West's Power Up theme. Nine different versions were created with tipped-on labels for nine different campaigns. Inside the box are letterhead, note cards, envelopes, information about the program, and other small gifts.

DESIGN FIRM Vaughn Wedeen Creative
ART DIRECTOR Steve Wedeen
DESIGNER Steve Wedeen
COMPUTER PRODUCTION Stan McCoy
ILLUSTRATOR Vivian Harder
COPYWRITER Steven Wedeen, client
PRINTER Champaign Fin Printing
PAPER Starwhite Vicksburg Double Thick Cover 130 lb. (record, sleeve, tracking card); French Construction Cement GreenText 70 lb. (jacket, insert); Fasson Crack 'N Peel (stickers)

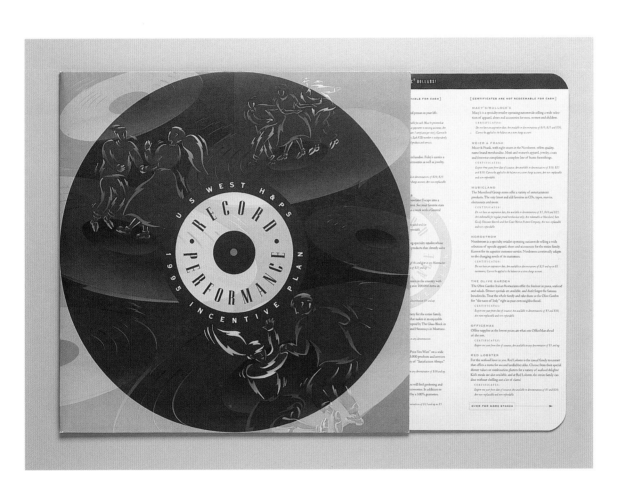

Vaughn Wedeen record Record Performance was the name US West gave to an employee-incentive program. This played off of the umbrella theme for the year's entire system, titled Making Music Together. Designers at Vaughn Wedeen Creative felt that packaging the program's printed material as an LP was an obvious choice. Some of the information about the program is die-cut into the shape of a record, which slips into the sleeve. Production was not particularly difficult. However, among all printers contacted to create the job, only one representative could figure out how to create the piece: That company got the job.

Pressley Jacobs Design Christmas tattoos Like many design firms, Pressley Jacobs Design sends out a holiday card to clients and friends. For this studio, the design of the piece is usually a collaboration of designers in the office who contribute their work or of vendors who contribute their services. The 1997 theme was tattoos, which the designers felt presented an interesting visual and conceptual play: The holidays are a time of personal expression through gifts, cards, and songs. What says personal expression better than body decoration? The tattoos' carrier and booklet were printed offset; the tattoos themselves were created with a temporary transfer process.

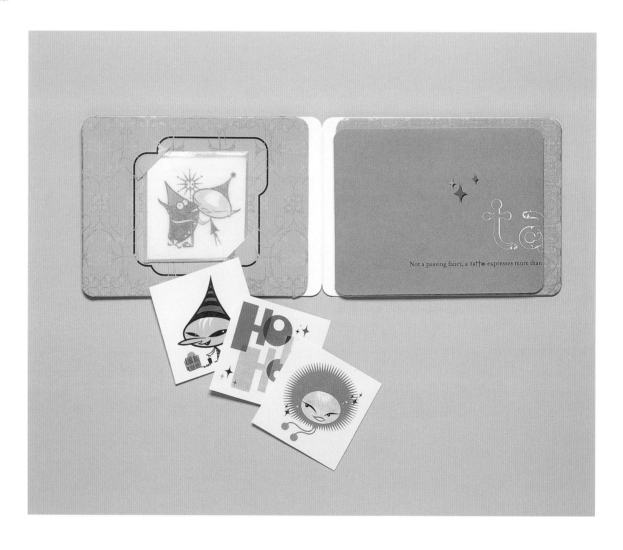

DESIGN FIRM Pressley Jacobs Design
ART DIRECTOR Jeff Clift
DESIGNER Jeff Clift
CREATIVE DIRECTOR Wendy Pressley-Jacobs
ILLUSTRATOR Kirstin Ulve
PRINTER Ace Graphics
PAPER Mohawk Superfine

Visual Dialogue Kent Dayton business cards Kent Dayton's very simple business cards do not include his complete address—at least not all in one place. Instead, designers at Visual Dialogue wrap type from front to back, forcing the holder to turn the card over—alternating between image and white space—suggesting the way in which photography captures a fleeting moment in time.

Visual Dialogue **DESIGN FIRM**
Fritz Klaetke **ART DIRECTOR**
Fritz Klaetke **DESIGNER**
Shear Color Printing **PRINTER**
Mohawk Options **PAPER**

Visual Dialogue Polly Becker Illustration stickers | Illustrator Polly Becker combines a variety of found objects and images in her work—leftover fragments of other people's lives, some long past. Her identity system, created by Visual Dialogue, works in a similar way. She can customize invoices, envelopes, mailers, and so on by applying stickers in various configurations. Each piece that leaves her office can be completely unique.

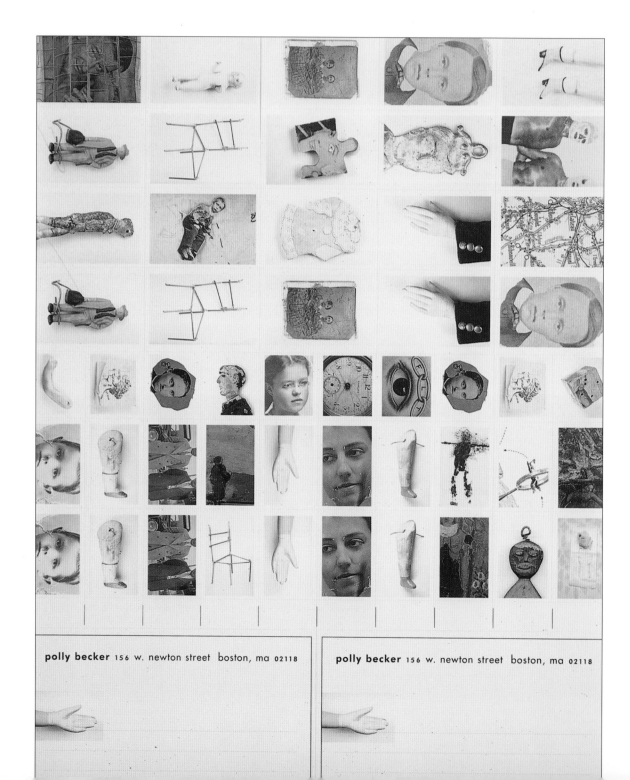

DESIGN FIRM Visual Dialogue
ART DIRECTOR Fritz Klaetke
DESIGNER Fritz Klaetke
ILLUSTRATOR Polly Becker
PRINTER Shear Color Printing
PAPER Crack 'N Peel

DESIGN FIRM Parachute Design, Inc.
ART DIRECTOR Heather Cooley
DESIGNER Heather Cooley
COPYWRITER Michael Atkinson
ILLUSTRATORS Mark Weakley (Chopin portrait);
Todd ApJones (hand lettering)
PHOTOGRAPHER Curtis Johnson
ADVERTISING AGENCY Clarity Coverdale Fury
PAPER French Butcher Off-White (letter and inside
lining of box); Fox River Quality Cover
("leather" strapping)

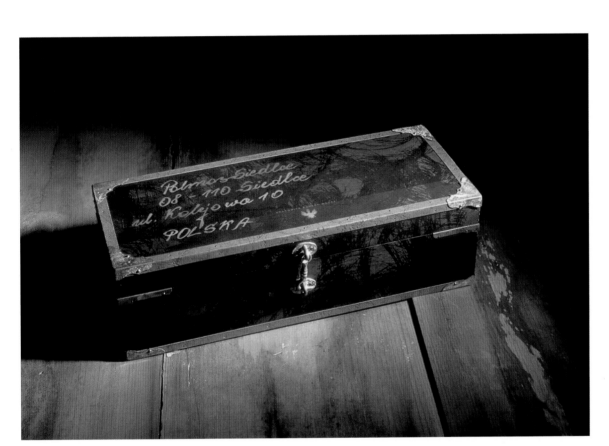

Parachute Polmos/Polska box The Chopin direct-mail box was a limited-edition piece sent to introduce

Chopin Vodka to a very targeted audience. All design choices were historical in nature, so authenticity was the

primary goal. The story behind the box: A small distiller in a tiny Polish town has protected a traditional recipe

for years and now would like to send a taste to you. A miniature steamer trunk, made of wood, carries the gift.

Its brown leather strapping is actually a leather-textured paper. The box's lining is printed on cheap butcher

paper, creating mottling and uneven color coverage, like an aged-satin liner. An enclosed letter is also printed

on butcher paper for an aged effect.

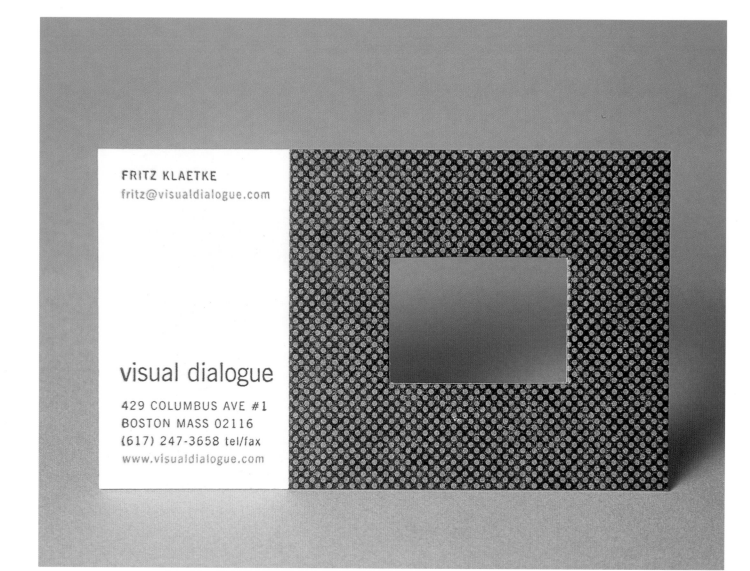

FRITZ KLAETKE
fritz@visualdialogue.com

visual dialogue

429 COLUMBUS AVE #1
BOSTON MASS 02116
(617) 247-3658 tel/fax
www.visualdialogue.com

DESIGN FIRM Visual Dialogue
ART DIRECTOR Fritz Klaetke
DESIGNERS Fritz Klaetke, Chris Reese
PRINTER Innerer Klang Press
PAPER Fox River Starwhite Vicksburg

Visual Dialogue business card The Visual Dialogue business card uses a framing device as its central metaphor, suggesting both the processes of observing and of isolating whatever is in the window. The simple die-cut window instantly causes the recipient to interact with the card. Letterpress printing refers back to the history of printing, while the dot pattern suggests the halftone screen used to reproduce images.

Miriello Grafico Gilbert Paper wheel The idea for the Gilbert Paper G3 Awards Call for Entries, created by

Miriello Grafico, is based on searching for a good idea, something all designers must do in order to create

great work. The client wanted a piece that designers would linger over and that used their paper products. So

the designers created a promo with three paper wheels, which the recipient can turn to form different images.

Visuals, type, and found art overlap each other on the transparent paper and present possibilities to inspire.

Miriello Grafico **DESIGN FIRM**
Ron Miriello **ART DIRECTOR**
Michelle Aranda **DESIGNER**
Ken West **PHOTOGRAPHER**
Gilbert Esse, Gilbert Gilclear, Gilbert Oxford **PAPER**

FUNCTIONAL PAPER **37**

DIMENSIONAL PAPER

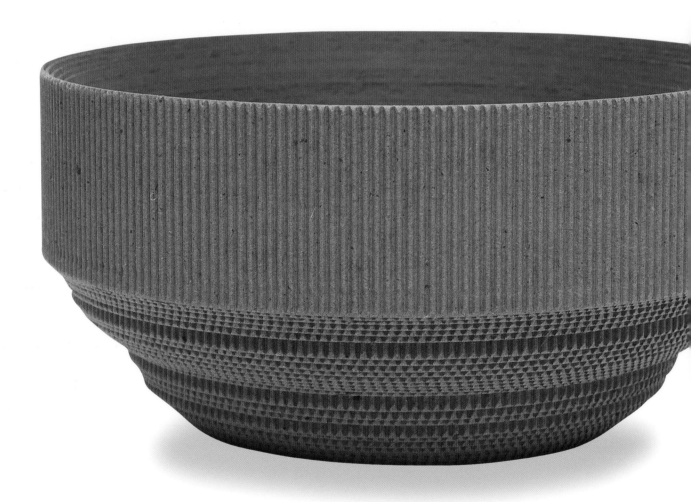

Folding pushes paper into the second and third dimensions: What was once a book lying lifelessly on the table can become a Slinky-like construction, stretching out for many feet; a run-of-the-mill greeting card can actually stand up and demand attention.

To fold or build with metal, you need special tools and a lot of power. If you want to bend glass, extremely high heat is necessary. Try to re-form almost any other material in the world—natural or man-made—and you need some auxiliary help.

However, you need only your own two hands and a bit of imagination to bend, twist, fold, and manipulate paper. And almost anything can be built with it, from packaging and books to pennants and even bowls (as illustrated by Love Packaging and Pangborn Design's examples shown in this section).

For a recipient accustomed to receiving press releases, booklets, letters, and more that are folded in half or in thirds, a clever folded or dimensional paper piece cannot be ignored. Even those who are unconcerned with design understand instantly that here is something new, something very, very unusual.

Pangborn Design Dry Pottery (p. 55)
Paper: Corrugated cardboard

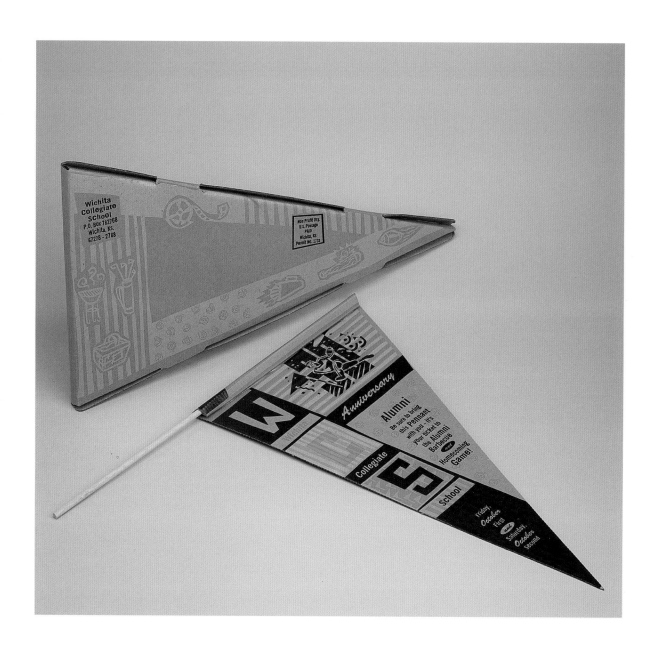

DESIGN FIRM Love Packaging Group
DESIGNER Tracy Holdeman
ILLUSTRATOR Tracy Holdeman
STRUCTURE Daryl Heame
PAPER Corrugated board

Love Packaging Wichita Collegiate School pennant When Love Packaging Group, a division of Love Box

Company, was asked to come up with an idea for an innovative mailer for a college alumni homecoming/

reunion event, the firm turned to the corrugated products and structural graphics for which it is known.

The pennant-as-ticket was a tremendous success: Nearly one-half of its two thousand recipients responded.

But packaging the triangular, dimensional piece and its stick required another unique element: a triangular,

tabbed mailer, designed to meet post office bulk-mail requirements.

DESIGN FIRM Peter Vogt (Stuttgart, Germany) and Neudel Verpackungen GmbH (Neckarbischofsheim) PAPER Strathmore Grandee, Gibraltar Gray (custom color), Cover 80

Peter Vogt and Neudel Verpackungen GmbH Lamy packaging A writing-instrument manufacturer with a real eye for design, Lamy originally used extremely high-end packaging to make its product stand out in the stores. But when new German environmental laws made the company change its packaging from plastic to recycled paper, an even more interesting system of ten boxes emerged. From paper-airplane-like boxes to octagonal jewel cases, the cleverly folded designs not only protect and show off the products, they also use almost no glue.

Karin Beck Sommersemester 98 For a brochure that detailed offerings during the 1998 summer semester at the University of Applied Technology, Economy, and Design of Liechtenstein, Karin Beck devised a modified Z-fold that allowed all departments of the university to be visible on either edge of the front of the design. Color coding matches a pattern already in use for the university.

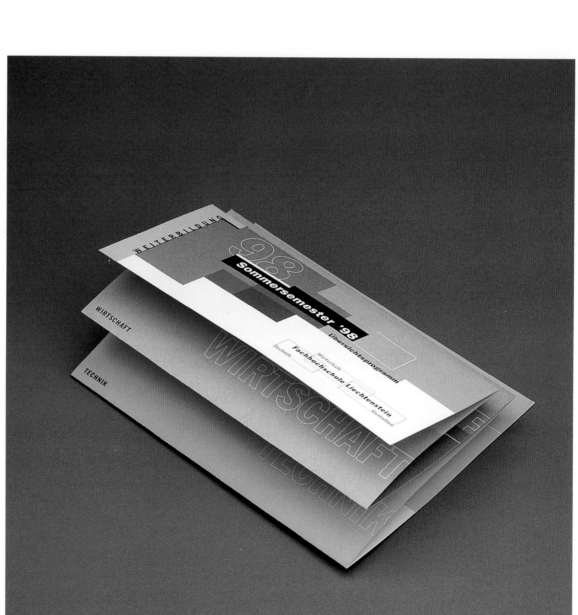

DESIGN FIRM Karin Beck, Grafische Gestaltung
ART DIRECTOR Karin Beck
DESIGNERS Karin Beck, Connie Kaufmann
PAPER Baumgartner Tauro Offset 120 gsm

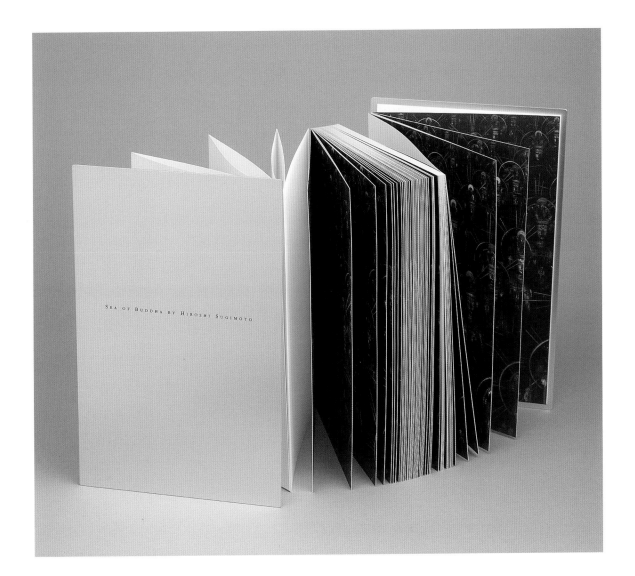

DESIGN FIRM Matsumoto, Inc.
ART DIRECTOR Takaaki Matsumoto
DESIGNER Takaaki Matsumoto
PHOTOGRAPHER Hiroshi Sugimoto
PAPER Van Nouveau 135 gsm

Matsumoto Buddha book | This limited-edition book, designed by Matsumoto, Inc., contains a series of photos taken by fine arts photographer Hiroshi Sugimoto. One thousand copies were produced to represent one thousand Buddhas; the entire edition, therefore, would contain one million Buddhas, which within Buddhism symbolizes infinity. All 120 pages in the book are glued together accordion-style (a common convention of sacred Buddhism books), bound between aluminum covers, and then slipped into a cloth-covered slipcase. To keep the book from getting bulky from all of the gluing, the edges of the paper at the seam were not folded inward and glued, but instead were kept flat with the backs of the pages glued together.

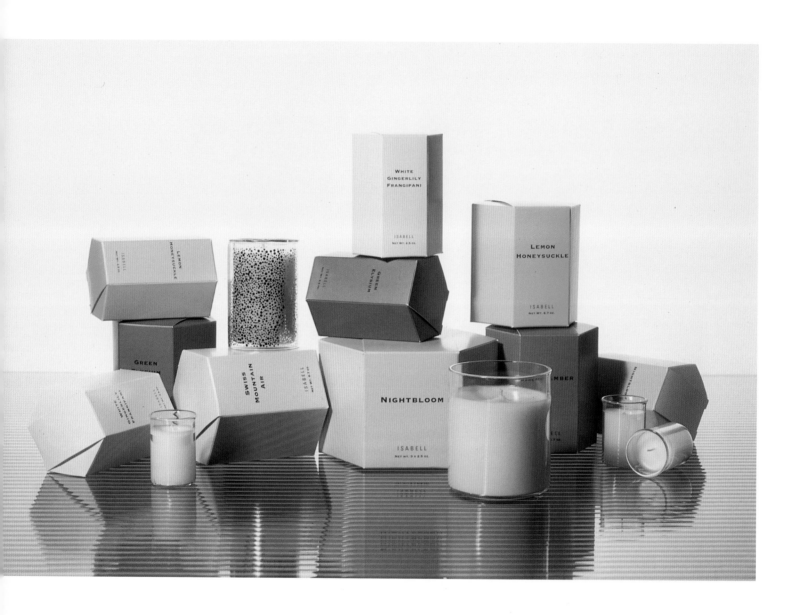

DESIGN FRIM Matsumoto, Inc.
CREATIVE DIRECTOR Takaaki Matsumoto, Robert Isabell
ART DIRECTOR Takaaki Matsumoto
DESIGNER Takaaki Matsumoto
TYPE Takaaki Matsumoto
PAPER Carolina board lined with white corrugated

Matsumoto Perfumes Isabell Scented candles have become very popular recently, so their packaging in the marketplace has had to become more and more competitive. Perfumes Isabell has a line of candles whose fragrances are described as fresh, natural, and unique. Matsumoto, Inc. was charged with creating packaging that matched those descriptors. The designers' solution was a hexagonal box constructed with conventional materials and procedures. Colors were chosen to reflect the delicacy of the individual scents and to coordinate with other packages.

Cahan & Associates Progenitor 97 annual report Bill Cahan, principal of Cahan & Associates, says that the annual report designed by his team for client Progenitor was incontrovertibly one of the lowest budget pieces they've ever completed. Cahan wanted to create a piece that worked like a brochure, but opened to a poster. The compelling design unfolds panel by panel, sharing information about the client's year. Then it opens into a memorable poster. The 10K form was printed separately and tucked inside. Cahan added that the design was so cost-effective that it came in under budget by one dollar, which the designer happily handed back to Progenitor's CFO.

Cahan & Associates **DESIGN FIRM**
Bill Cahan **ART DIRECTOR**
Bob Dinetz **DESIGNER**
Bob Dinetz **ILLUSTRATOR**
Jay Blakesberg **PHOTOGRAPHER**
Carrie Wick, Bob Dinetz **COPYWRITER**
Warren Patina Matte Text 80 lb. **PAPER**

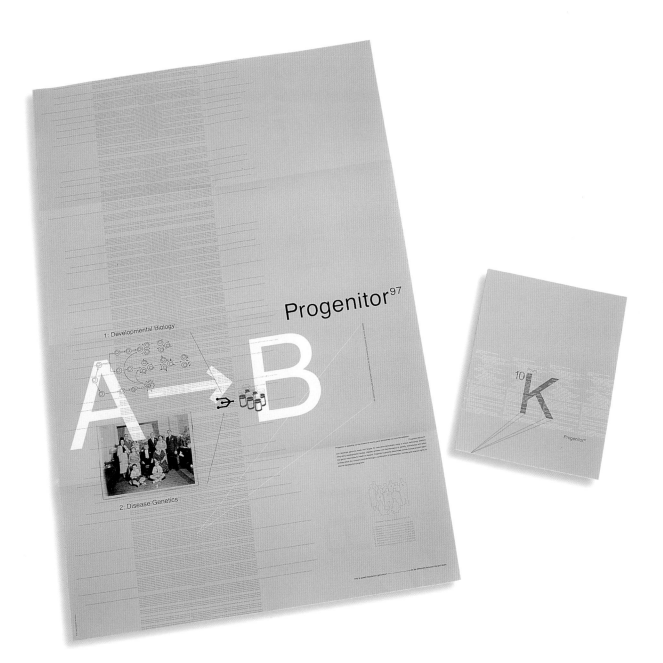

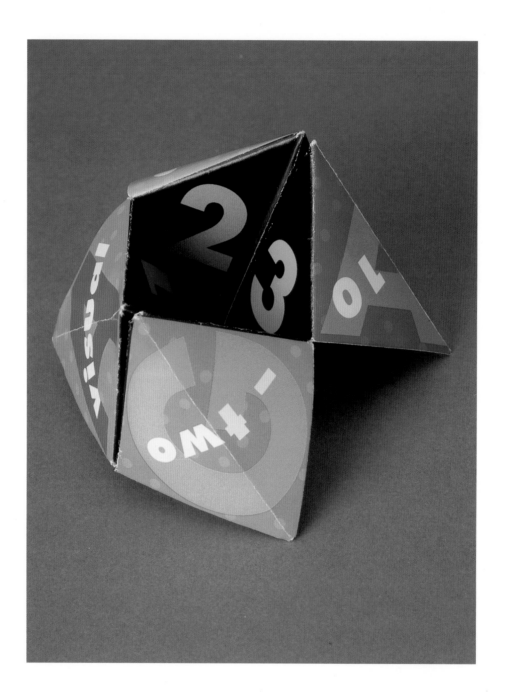

DESIGN FIRM Visual Asylum
CONCEPT Mae Lin Levine, Amy Jo Levine
DESIGNERS Mae Lin Levine, Amy Jo Levine,
Joel Sotelo, Charles Glaubitz
ILLUSTRATOR Joel Sotelo
PAPER Potlatch McCoy Gloss 100 lb. text

Visual Asylum game This Visual Asylum promotion piece was given away at a design conference to anyone who attended scheduled studio tours. It's a grown-up version of a grade-school toy that almost everyone has made at one time or another. As the tours progressed, recipients could use the little fortune-teller to find things to do or see or eat in San Diego. A slick, bright paper with strikes on all the fold lines made assembly a snap.

Ashley Booth Design Christmas-tree card Ashley Booth of Ashley Booth Design felt that clients and friends on her holiday mailing list should get a "complete Christmas kit": a Christmas tree, a present, something to eat and drink, and a Father Christmas figure. So she created a tree that unfolds to reveal her holiday wishes for recipients, and she tucked a treat and the figure inside the wrapped gift.

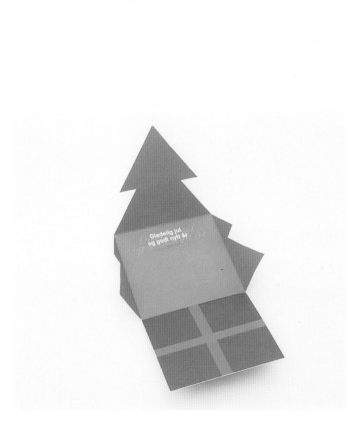

Bohatsch See you soon folder Bohatsch Graphic Design's concept for a folder created to explain a museum project in Vienna looks much like any other booklet: a modest 5 3/16-by-8 3/4-inch design with a peek-a-boo window added to the interior. But inside, all of the text and graphics are printed on a single extended gatefold page, made necessary by the use of maps and other oversized graphics. As soon as the reader opens the book, the cover headline's promise—see you soon—is delivered.

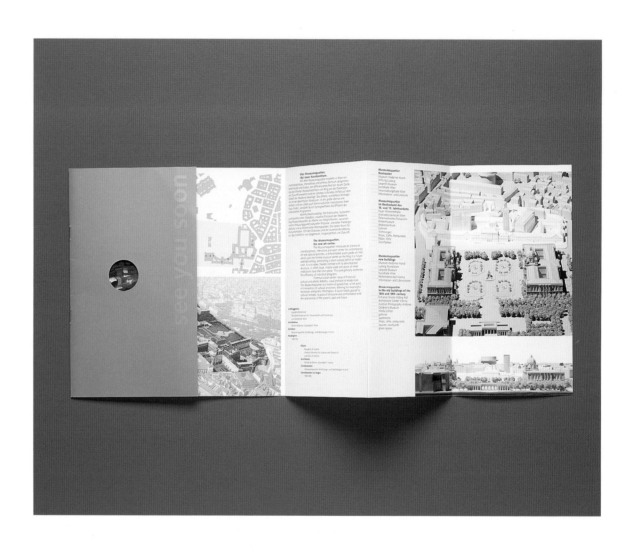

DESIGN FIRM Bohatsch Graphic Design GmbH
DESIGNER Walter Bohatsch
EDITOR Brigitte Huck
TRANSLATION Werner Rappl
PRINTER Graphische Kunitanstalt
PAPER Unimat-Pro 170 gsm and 250 gsm cover

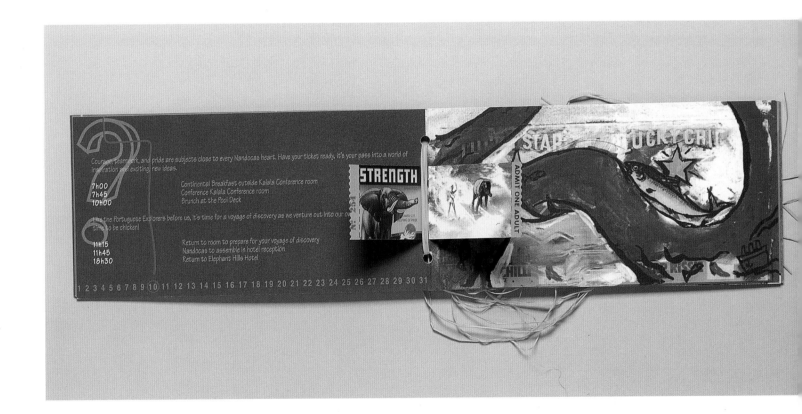

Cross Colours Ink **DESIGN FIRM**
Joanina Pastoll, Janine Rech **CREATIVE DIRECTORS**
Ria Krafft **DESIGNER**
Ria Krafft **ILLUSTRATOR**
David Pastoll **PHOTOGRAPHER**
Rive Design 120 gsm and 250 gsm **PAPER**

DIMENSIONAL PAPER 49

Cross Colours Nando Pause book Nando's is a South African company that became known originally for its Portuguese grilled peri-peri chicken. Today, the company offers much more through its 120 stores worldwide—fast food, sit-down meals, bottled sauces, chicken products, even clothing. The Pause in the Journey booklet, designed by Cross Colours Ink, was an invitation to a yearly company conference, and an accounting of Nando's first ten years. Bound into each spread is a little folded ticket, which granted the recipient admittance to various conference events.

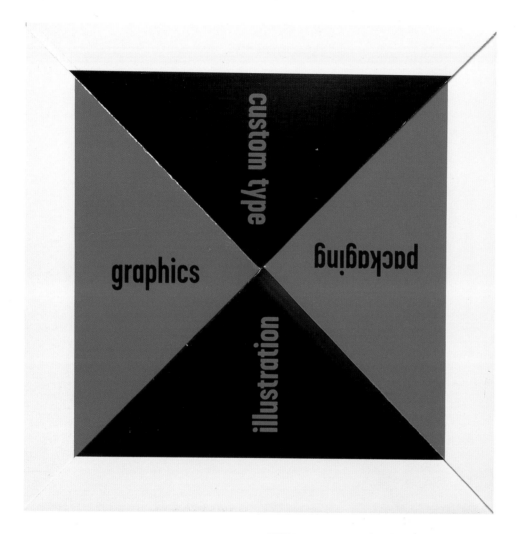

DESIGN FIRM blackcoffee design

DESIGNERS Mark Gallagher, Laura Savard

ILLUSTRATOR Mark Gallagher

PAPER Printer's house stock, white dull coated

blackcoffee design self-promo blackcoffee design, a young firm with plenty of clever ideas, is making itself known with innovative designs such as this intricately folded self-promotion. Designers Mark Gallagher and Laura Savard wanted to stress their firm's package design work, so they devised a flat box that recipients must open to retrieve the promotional message. The promos are folded in-house on an as-needed basis and are mailed in semicustom envelopes or used as leave-behinds. Recipients, Savard says, always respond favorably.

@KA wedding invite Albert Kueh of @KA bucked the tradition of pricey envelopes nested inside other pricey envelopes when he created this truly unusual wedding invitation. The invitation itself is folded in such a way as to form its own envelope. Kueh based his folds on the notion of an old-fashioned love letter, sweetly appropriate for the subject matter. Dots were printed on the sheets to assist in the folding.

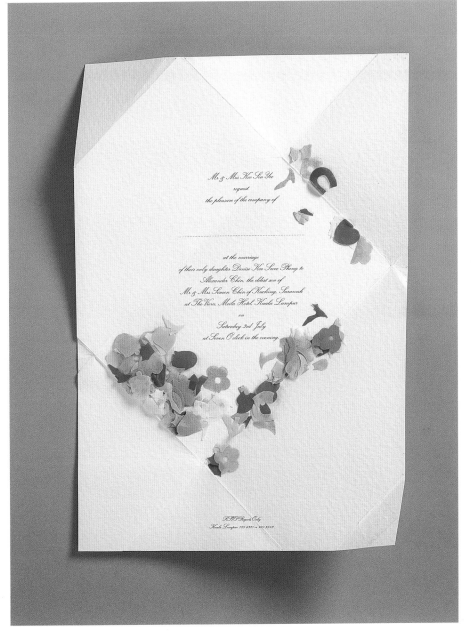

Vrontikis Design Zest invition Vrontikis Design Office's Tokyo restaurant client wanted a Wild West theme

for an invitation to his Tex-Mex restaurant, Zest. For the design solution, principal Petrula Vrontikis turned

to an approach for which her studio is well-known: Intricately folded paper pieces. She folded small pieces

of paper together until she devised a pattern that integrated Southwestern colors and revealed information

in stages. The finished design neatly mixes the Tex-Mex theme with the feel of a Japanese folding book.

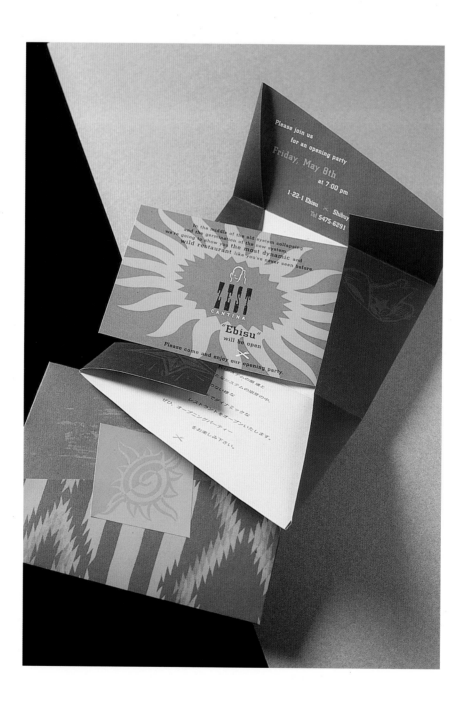

DESIGN FIRM Vrontikis Design Office
ART DIRECTOR Petrula Vrontikis
DESIGNERS Petrula Vrontikis, Kim Sage
PRINTER Donahue Printing
PAPER Simpson Quest

Ashley Booth Form 98 invitation The multiple design disciplines that comprised the Form 98 show—design, illustration, environmental design, and so on—prompted Ashley Booth's idea for creating an exhibition invitation that also could also be made into a cube. Because of this range, she felt that the invitation should be three-dimensional as well as two-dimensional: The piece mailed flat, but is easily assembled into a cube without the use of fasteners or adhesives.

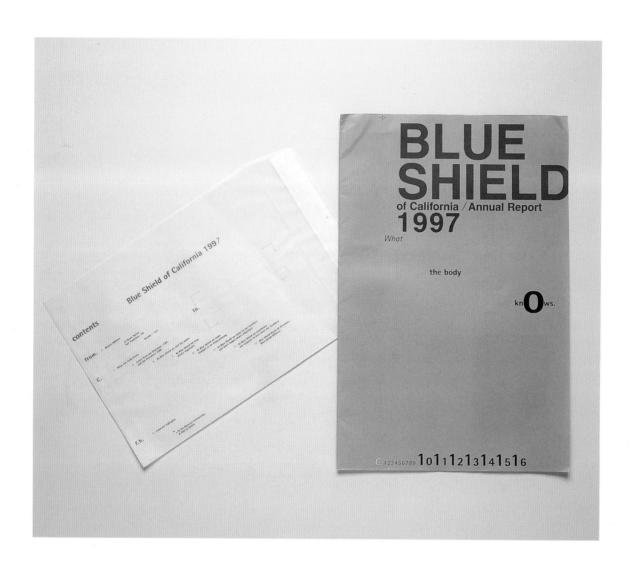

DESIGN FIRM Sterling Design
CREATIVE DIRECTOR Jennifer Sterling
WRITER Lisa Cirron
PHOTOGRAPHER Marko Lavrisha
PRINTER H. MacDonald Printing
PAPER Various Mondi products

Sterling Design Blue Shield 97 annual report Sterling Design's client Blue Shield asked the design firm to create an annual report with a bold, aggressive look to project the message of a successful year—none of the warm- and-fuzzy messages normally associated with health care. The design firm solved the design problem partly with conceptual photography inside, but also with a boldly oversized (12-by-18-inch) page size. For mailing-cost considerations, the annual report was folded in half—highly unusual for such a document—and was mailed in a transparent envelope.

Pangborn Design Dry Pottery After extensive experimentation while searching for new packaging

solutions, Dominic Pangborn of Pangborn Design happened upon his firm's Dry Pottery product. A roll of

corrugated paper can be shaped and reshaped like clay into useful and decorative products. By gently

shaping the roll of corrugated cardboard, bowls and other containers can be formed. If a mistake is made,

the roll is easily remade and can be shaped again and again. Pangborn Design now sells the product in two

different kits.

Pangborn Design zigzag box and cone box The purpose of these unique boxes, created by Pangborn

Design, was to develop an innovative package from a single sheet of paper or board without the use of

glue. Through creative use of die-cuts and folds, truly unusual paper shapes are formed. The boxes are now

sold in specialty shops and they are used for the packaging of other Pangborn Design products.

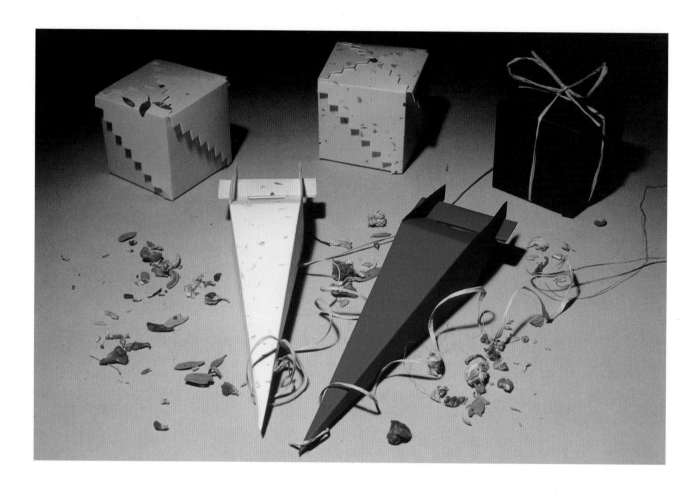

DESIGN FIRM Pangborn Design, Ltd.
DESIGNER Dominic Pangborn
PAPER Various

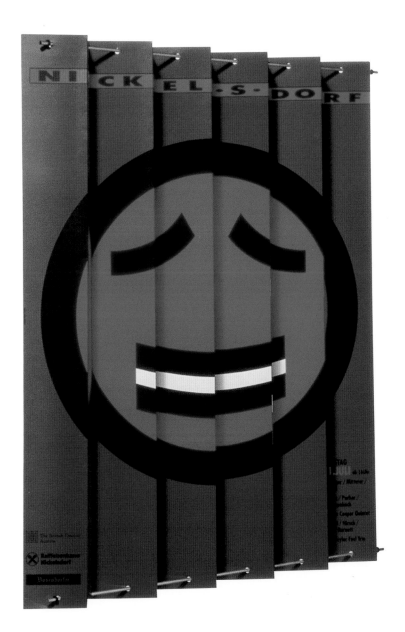

Sagmeister Inc. zigzag poster The idea for the zigzag-folded, 25-by-23-inch Nickelsdorfer

Konfrontationen poster occurred to designer Stefan Sagmeister from the turning billboard installations

commonly seen in airports. He created a number of small dummies to figure out the structure of the piece,

then designed the whole layout on the computer. The posters were scored, folded, and hole-punched at the

printer. The custom-cut aluminum rods were inserted through the posters at the point of installation,

generally cafes and stores.

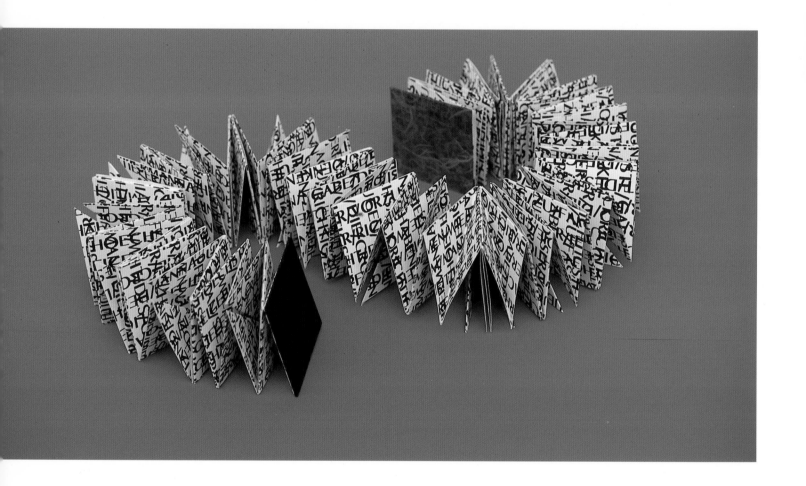

Anna Wolf paper Slinky book Artist Anna Wolf loves to fold paper and has created what she calls "book-structures" for many years. Each page of this Slinky-like book carries type that conveys variations and double prints of the letter *A*. The 8 1/2-inch-square pages can be pushed all the way shut or they can be pulled out into accordion-like sculptures.

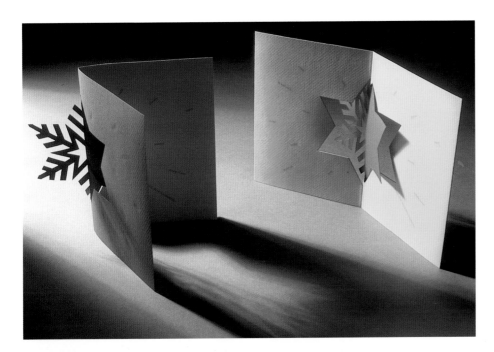

Chermayeff & Geismar **DESIGN FIRM**
Steff Geissbuhler **DESIGER**
Continental Anchor Ltd. **DIE-CUTTING, ENGRAVING**
Continental Anchor Ltd. **PRINTING**
Star Card—NeenahClassic Columns, **PAPER**
Duplex Cover (Red Pepper and Stucco),
120 lb. ; Star and Snowflake—twocover
stocks laminated together; Star and
Tree–Semperite Foil Silver 10 point, 1 sided

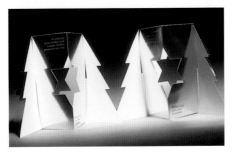

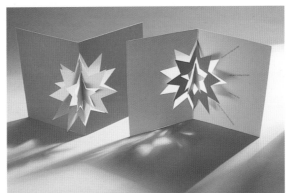

Steff Geissbuhler holiday cards Each year Steff Geissbuhler of Chermayeff & Geismar creates holiday

cards to send to Jewish and Christian friends. To make the cards function for Hannukah and Christmas, the

designer used a combination of stars: five-pointed for the United States, six-pointed for the Star of David,

and eight-pointed for the star of Bethlehem. (He also inadvertently embraced yet another belief—Islam—

when he included a ten-pointed star.) One card combines the Star of David with a snowflake; various wishes

emanate from the center. Another card is made from two identical, interlocking die-cut pieces. The angles

of the star and the tree are the same, making the construction, folding, and reflection work. Friends have

come to anticipate these unique cards eagerly: Geissbuhler says he has been making such cards for a long

time and has not run out of ideas yet.

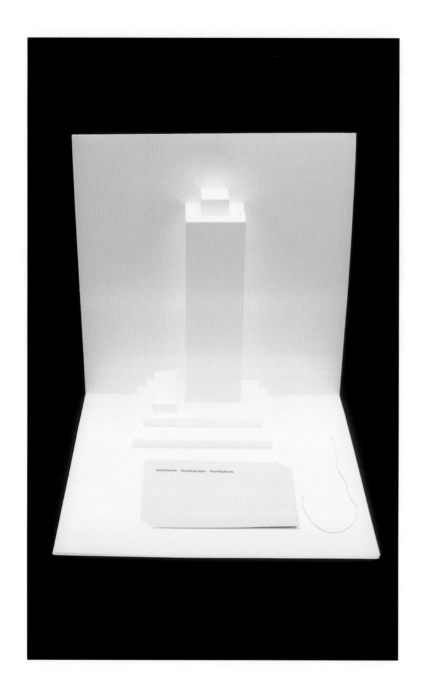

DESIGN FIRM Thomas Manss & Company
ART DIRECTOR Thomas Manss
DESIGNER Thomas Manss
PAPER Edelweiss card stock

Thomas Manss Hotel Arts Barcelona invitation Hotel Arts Barcelona in Spain is the first foray into Europe by the American hotel company Ritz Carlton. The five-star hotel's name arises from its fine collection of paintings and sculptures. The invitation for the hotel's opening is an elegant mirror of the building's structure. Printed from a single sheet of paper, it has no printing, just a series of cuts and folds that cause the building to pop up when the invitation is opened. All details of the party are printed on a ticket inserted into the card.

Parachute Design Chopin vodka box The Chopin vodka gift box, created by Parachute Design, is merchandised next to its bottle in the retail environment. The concept derived from very old gift-giving traditions, whereby lidded paper boxes were tied with ribbons for presentation, like an early version of wrapping paper. In this tradition, the molding of the paper pulp would create a mottling and swirling of the paper and pigment around the box shape. Texture and color were also added to the strip seal to imply age and to add a layer of soft detail.

DESIGN FIRM Parachute Design
ART DIRECTOR Heather Cooley
DESIGNER Heather Cooley
COPYWRITER Jerry Fury
ILLUSTRATOR Mark Weakley
HANDLETTERING Todd ApJones
PHOTOGRAPHER Curtis Johnson
PAPER Strathmore American, ProTac Pressure Sensitive, Curtis Corduroy (liner) .020 CBS Board (box construction)

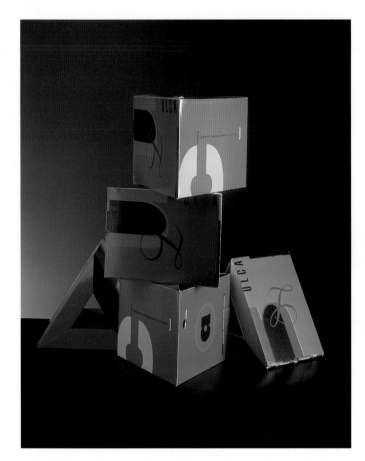

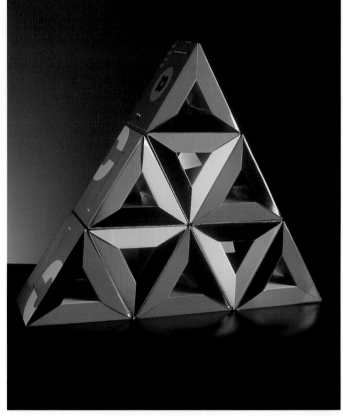

DESIGN FIRM Emery Vincent Design
PAPER B-fluted corrugated cardboard

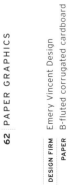

Emery Vincent Graduate Connection triangles | Emery Vincent Design created this display unit for The Graduate Connection of the University Language Centres of Australia, which produces publications for universities. The display's triangular building blocks can be used alone or stacked and configured in various ways, and can be used for display or for shipping. Each box opens for access to brochure storage, one hundred A4 brochures per container.

Emery Vincent Steelcase cube calendar | This Steelcase calendar was designed by Emery Vincent Design to sit on office desks and promote the client's products to customers in the Asia Pacific region. The center of the constructed object contains a cube on which the company identity appears. Each of the six sides of the calendar features two months of the year, with Asian holidays highlighted in red.

NAKED PAPER

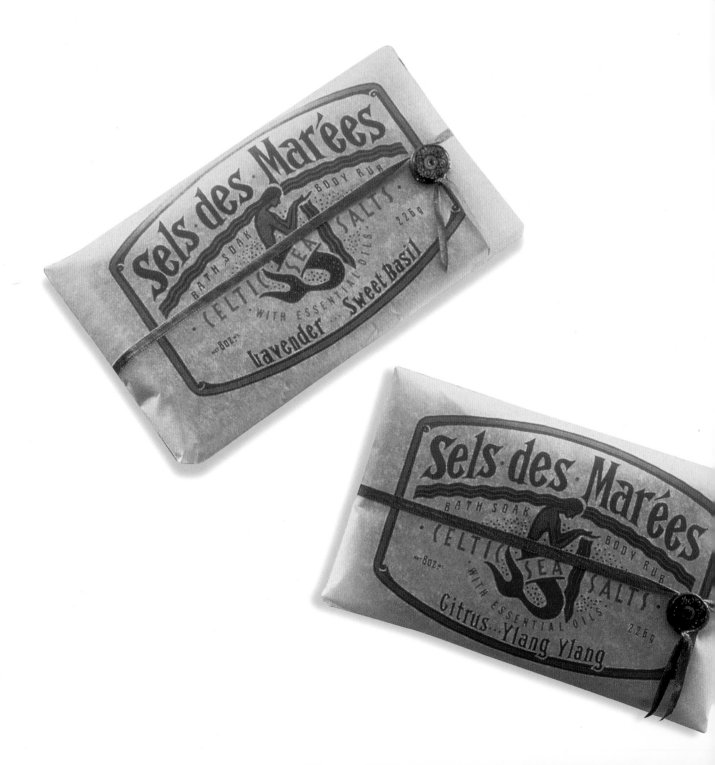

With all of the production and printing processes available today, it is easier than ever to take advantage of one, two, or more of these processes in order to build the kind of visual magnetism every design should have. But to fall back on the most basic element of printing— the paper—is to accept a more exacting challenge.

Granted, never before has there been more unusual, distinctive, even conceptual papers available. But the designs featured in this section do not depend on glitz or novelty to succeed. Instead, they draw on paper's inherent form or beauty. They build on normal paper conventions to make their statements.

For instance, when Cahan & Associates was charged with communicating its client's message to CFOs, the firm borrowed from a form that would be very familiar to financial types: the exact shape and size of the *Wall Street Journal*. Designer Deborah Schneider wanted her handyman client's stationery system to speak for itself, so she specified down-to-earth papers that looked as though they had been found around the house.

The key is to use paper conceptually. The resulting solution should be so appropriate that it excludes all other possibilities: No other answer would have worked as well.

Sayles bath salt packaging (p. 70)
Paper: Curtis Parchment

Bailey Lauerman Western Printing opening The medium was definitely the message in this grand-opening announcement for Western Printing Company (now Xpedex), designed by Bailey Lauerman & Associates: It opens in a very grand way. Because Western's new warehouse would stock paper, in a facility markedly larger than the previous one, the perfect answer seemed to be a very large piece of paper with a minimal message printed at its center. The unfolding of the piece required recipients to become more involved with the message.

DESIGN FIRM Bailey Lauerman & Associates
CREATIVE DIRECTOR Carter Weitz
COPYWRITER Mitch Koch
PAPER Hammermill Opaque Vellum, Cream White 60 lb.

DESIGN FIRM Sagmeister, Inc.
DESIGNERS Stefan Sagmeister, Mike Chan
PHOTOGRAPHER Bela Borsodi
PAPER Lightweight bible paper

NAKED PAPER **67**

Sagmeister Inc. Songs of Maybe CD booklet | Stefan Sagmeister was working in Hong Kong when a European jazz band asked his firm to complete a CD cover/booklet for a release recorded (partly) in an Alpine church. Sagmeister's studio adopted a Biblical approach—changing the styles of typography in the booklet to reflect the changing styles of the music. Low-cost production overseas allowed for a forty-page booklet on semitransparent bible paper, including a fabric band bookmark, all within the client's budget.

Sagmeister Inc. dollar-bill business card For the opening of its new T-shirt store in New York City, Gross &

Klein required a business card. In its very open briefing to Sagmeister, Inc., the store owners specified that one

card could not cost more than one dollar U.S. for production. So Stefan Sagmeister printed the business cards

directly on one-dollar notes and simply folded them up. The client loved the concept, but the store never

opened and the design was not implemented.

DESIGN Stefan Sagmeister
CONCEPT Stefan Sagmeister

Design: M/W **DESIGN FIRM**

Champion Benefit cover and spine; **PAPER**
Appleton Paper's Utopia, Jazz,
Woodbine Crane's Kid Finish
and Translucent

NAKED PAPER | **69**

Design: M/W Dickson's notebook When it comes to being catered to—paper-wise—nobody gets better

treatment than graphic designers. This capabilities booklet, distributed at an AIGA convention in New Orleans,

is a Griffin & Sabine-style production, filled with tucked-in notes, souvenirs, and other paper mementos from a

visit to the city. Two pieces of black, pressed chipboard are glued to the front and back of the book, completing

the illusion of a scrapbook.

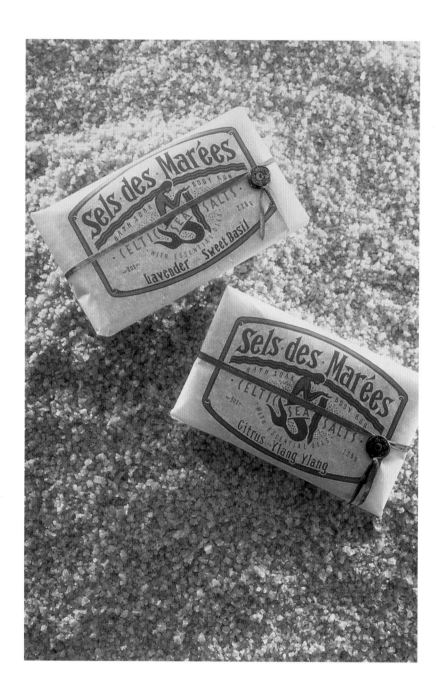

DESIGN FIRM Sayles Graphic Design
ART DIRECTOR John Sayles
DESIGNER John Sayles
PAPER Curtis Parchment

Sayles Design bath salts packaging Rather than use a more traditional bottle or box to hold his client's bath-crystals product, John Sayles felt that a transparent parchment pouch, printed with product information and tied shut with a ribbon and a charm, was more expressive. The nearly clear paper mirrors the translucency of the crystals, and it allows the buyer to glimpse the product before buying.

Henderson Tyner Sharonview annual report An uncoated, canvas-textured sheet turns the touching photography used in the Sharonview Federal Credit Union's annual report into a series of peaceful portraits. The client's goal was to evoke emotion and a sense of comfort in people who bank with the firm. Designers at Henderson Tyner Art Co. specified the textured sheet and rich duotones so that readers could see and even feel the client's philosophy of family-oriented, intimate service. The words-within-words concept subtly suggests that there is even more than meets the eye here.

DESIGN FIRM Henderson Tyner Art Co.
ART DIRECTOR Troy Tyner
DESIGNER Troy Tyner
COPYWRITER Stephen Young
PHOTOGRAPHER Wyndstone Mylar
PAPER Mohawk Tomahawk, Cool White, 80 lb. cover

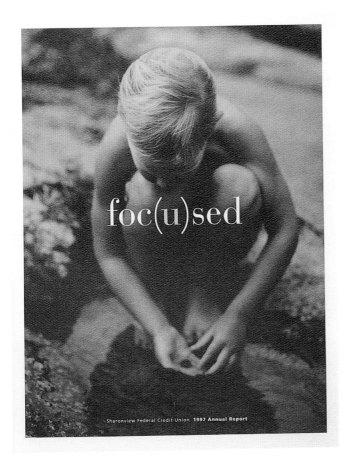

Sharonview's purpose is to become our member-owners' primary financial partner.

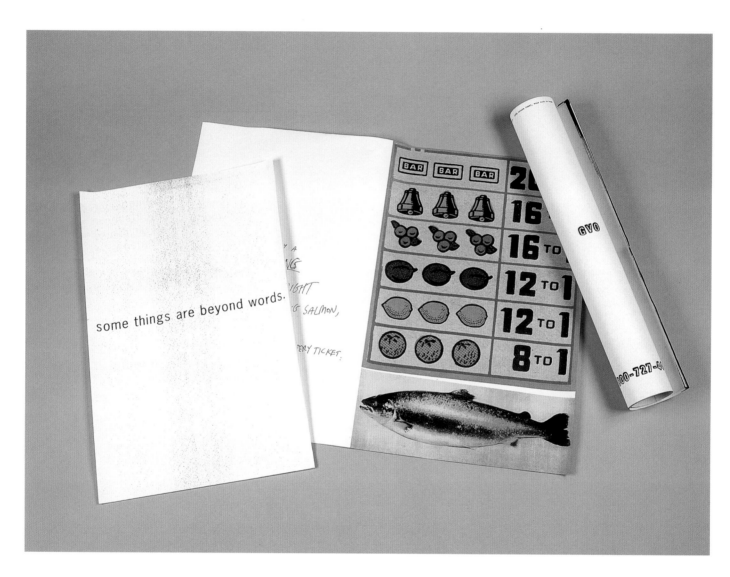

some things are beyond words.

DESIGN FIRM Cahan & Associates
ART DIRECTOR Bill Cahan
ILLUSTRATORS Bob Dinetz, Gary Baseman
COPYWRITER Stefanie Marlis
PRINTER White Oak Printing
PAPER Simpson Opaque Smooth Book 50 lb.

Cahan & Associates GVO promotion Cahan & Associates wanted to create a brochure for its client, the industrial design firm GVO, that was completely atypical and would go directly to CEOs and CFOs. So Cahan designers borrowed an icon from their world and developed an extremely oversized brochure the same size as the *Wall Street Journal*. A new so-called edition in the direct-mail campaign was mailed every seven to ten days, bundled, in a plastic bag as a newspaper would be.

Cahan & Associates **DESIGN FIRM**
Bill Cahan **ART DIRECTOR**
Sharrie Brooks **DESIGNER**
Ross MacDonald **ILLUSTRATOR**
Riegel Jersery Leatherette White Cover **PAPER**

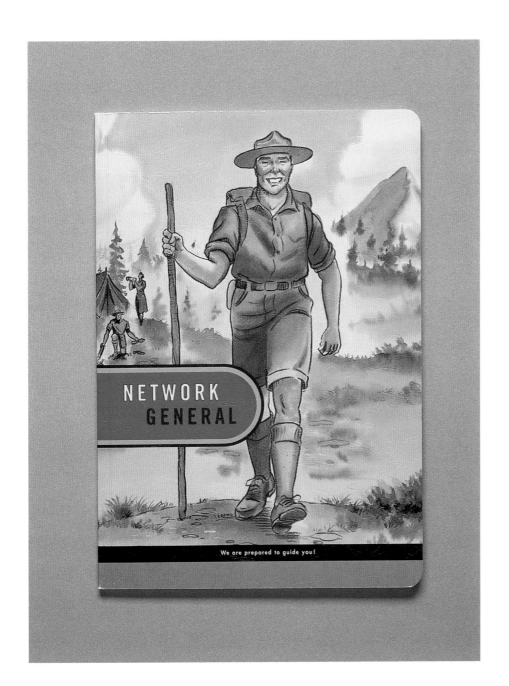

Cahan & Associates Network general report So much information is available through intranets today that a company's network can easily become an unnavigable wilderness of data. In its annual report, Network General wanted to convey its role as a leader in network management. So Cahan & Associates created a guidebook-like publication with a leatherette cover and period illustrations that together instantly speak of the nature of confident leadership.

DESIGNER Susan Skarsgard
PAPER Twinrocker Handmade Paper

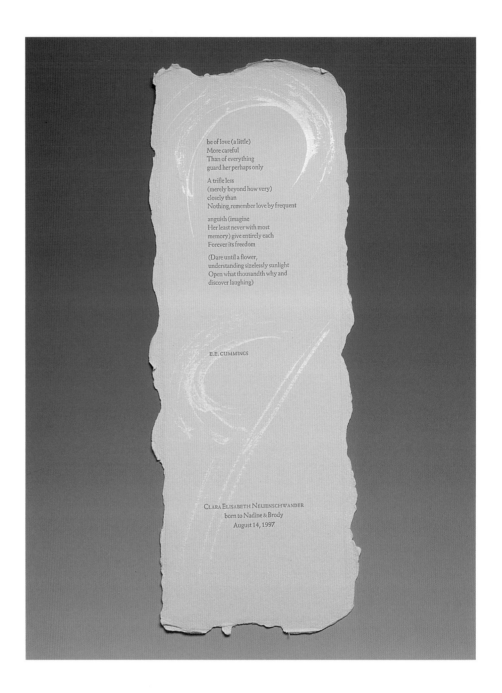

be of love (a little)
More careful
Than of everything
guard her perhaps only

A trifle less
(merely beyond how very)
closely than
Nothing, remember love by frequent

anguish (imagine
Her least never with most
memory) give entirely each
Forever its freedom

(Dare until a flower,
understanding sizelessly sunlight
Open what thousandth why and
discover laughing)

E.E. CUMMINGS

CLARA ELISABETH NEUENSCHWANDER
born to Nadine & Brody
August 14, 1997

Susan Skarsgard birth announcement Like a baby's skin, the surface of this handmade paper is soft, smooth, and wonderful to touch. Susan Skarsgard letterpress printed and hand-painted this birth announcement as a gift for friends, using a sheet formed with a natural deckle.

Susan Skarsgard GM design award and folder The foil stamp on the General Motors award certificate matches the iridescence of the truly unusual folder in which the certificate sits. Designer and letterer Susan Skarsgard says the wavy-lined stock, which subtly suggests tire tracks, was easy to work with. In fact, the opposite side of the folder carries an involved die-cut.

Deborah Schneider Housewise stationery Deborah Schneider Design created the identity for Housewise, a

company that provides just about any service that people require in or around their homes. The designers

chose different shades of the same line of paper to support the idea that the sheets were just found around

the house. The stock's soft, subtle tones also created a friendly, unassuming feel.

DESIGN FIRM Deborah Schneider Design, Inc.
CREATIVE DIRECTOR Deborah Schneider
DESIGNER Belinda Bowling
PAPER French Durotone, Packing Gray liner 70 lb. text (letterhead); French Speckletone, Chipboard 70 lb. text (envelope); French Durotone, Packing Carton 145 lb. cover (business card)

Peterson & Company Texas Instruments brochure The press run for this Texas Instruments booklet was 140,000 pieces and involved thirteen different language versions. So its designers at Peterson & Company wanted to maximize the use of paper on press. The finished design permits a complete brochure to be cut from one sheet of 26-by-40-inch paper, including the cover and a die-cut cube template that the recipient assembles. The front and back covers comprise a single sheet that wraps around the back and then folds to create both covers, which saved money in binding and hid the spiral binding.

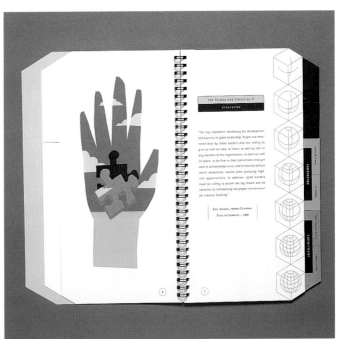

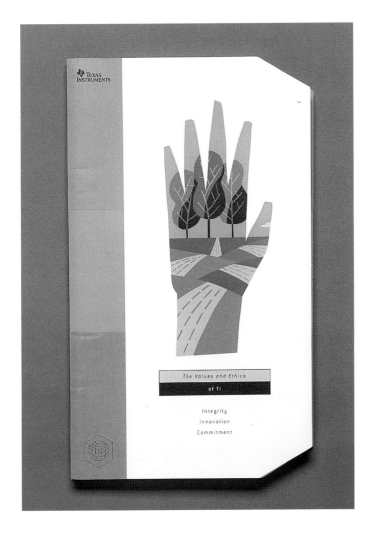

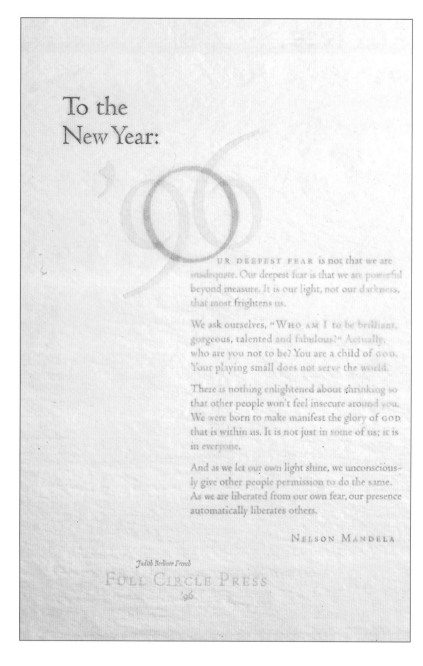

To the
New Year:

OUR DEEPEST FEAR is not that we are
inadequate. Our deepest fear is that we are powerful
beyond measure. It is our light, not our darkness,
that most frightens us.

We ask ourselves, "WHO AM I to be brilliant,
gorgeous, talented and fabulous?" Actually,
who are you not to be? You are a child of GOD.
Your playing small does not serve the world.

There is nothing enlightened about shrinking so
that other people won't feel insecure around you.
We were born to make manifest the glory of GOD
that is within us. It is not just in some of us; it is
in everyone.

And as we let our own light shine, we unconscious-
ly give other people permission to do the same.
As we are liberated from our own fear, our presence
automatically liberates others.

NELSON MANDELA

Judith Berliner French

FULL CIRCLE PRESS
'96

DESIGN FIRM Bob's Haus
DESIGNER / LETTERER Bob Dahlquist
PRINTER Full Circle Press
PAPER Simpson Teton (base); Millers Falls
EZ Erase typing paper (flysheet)

Bob Dahlquist 1996 New Year's card Bob Dahlquist designed this Full Circle Press New Year's card to maxi-

mize the inherent qualities of letterpress printing on a thick, tactile sheet. Gray ink was used for the main text,

with a very lightly tinted varnish in the supporting text, to emphasize the highlight and shadow of the imprint

in the paper. The printing on the transparent flysheet adds another layer to the visual experience.

Michael Bartalos Nocturne illustration Nocturne is the front cover of artist Michael Bartalos's boxed set of fifty postcards printed with cut-paper illustrations created when he worked in Japan. The background is hand-made paper that contains actual strips and stalks of bark and grass. The illustrator allowed the textured background to drive the flat foreground image—made from intensely dyed Japanese papers—and to interact with it, as well.

Miriello Grafico Carrier Johnson Wu book Miriello Grafico developed the cover of this Carrier Johnson Wu portfolio book as part of a system of tools the client could use for a long time. The contents of each portfolio sent out can be customized, then bound between the chipboard covers, which can also be used as a presentation folder. The die-cut adds dimension and color to the chipboard.

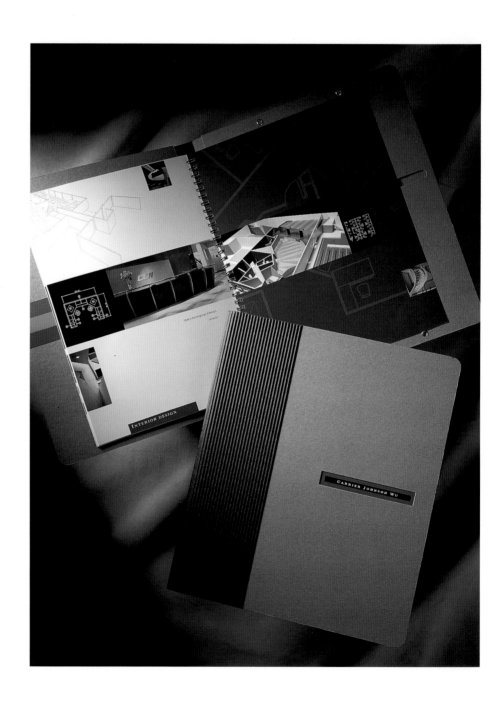

DESIGN FIRM Miriello Grafico
ART DIRECTOR Ron Miriello
DESIGNERS Ron Miriello, Michelle Aranda
PRODUCTION Maureen Wood
PAPER Chipboard (cover); corrugated board (spine); vellum and various text papers (inside)

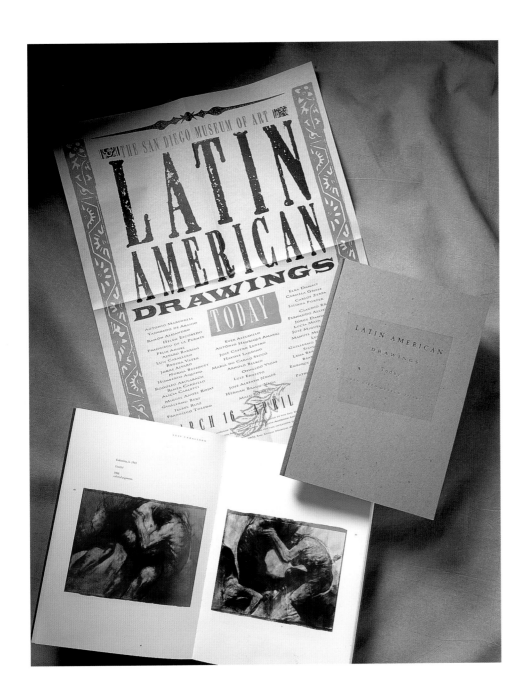

Miriello Grafico **DESIGN FIRM**
Ron Miriello **ART DIRECTOR**
Michelle Aranda **DESIGNER**
Dean Amstutz **PRODUCTION**
Chipboard (cover); Gilbert Esse (interior) **PAPER**

NAKED PAPER **81**

Miriello Grafico Latin American drawings catalog Letterpress printing of distressed, classical type adds

elegance to the chipboard used for the cover of this museum catalog. Designed by Miriello Grafico, the idea for

the catalog's binding—the spine stock is tucked under the cover stock—came from an antique children's

book found by one of the studio's designers. Principal Ron Miriello says he wanted the book's design to reflect

the simple, direct and visceral feeling of the art featured in the museum's show.

DESIGN FIRM Sterling Design
ART DIRECTOR Jennifer Sterling
DESIGNER Jennifer Sterling
COPY WRITER Tim Mullen
PHOTOGRAPHER Dave Magnusson
PAPER Esse Tan; Gilclear Cream

Sterling Design Pina Zangaro catalog Rather than clutter product pages of Pina Zangaro catalogs with type, Sterling Design decided to place product descriptions on transparent overleafs that interplay with the photography below. Opposite each product shot are the product designer's sketches, which sets Pina Zangora's products apart as the originator of these types of products in a market plagued with knock-offs. The vellum sheets reinforce the sketchbook nature of the catalog.

Telefonseelsorge | 1996

Peter Felder Grafikdesign **DESIGN FIRM**

Biotop (transparent sheet); Gmund Brillanca **PAPER**
(silver paper); Strathmore Americana
(red paper); and packing paper
(brown stock)

NAKED PAPER **83**

Vorwort | In sozialen Dienstleistungen und
sozialen Einrichtungen wird zur Zeit sehr
viel über Qualitässicherung, Qualitäts-
management und Qualitätszertifizierung
nachgedacht. In Zeiten knapper werdender
Ressourcen sind Effektivität und Effizienz
gefragt. Es wird untersucht, ob das ange-
botene Produkt der Kundennachfrage auch
entspricht. Man schaut ab in der Betriebs-
wirtschaft, überimmt Bezeichnungen, die für
soziale Dienstleistungen und Einrichtungen
lange nicht gebräuchlich waren. Der Jahres-
bericht 1996 besteht aus verschiedenen
Papiersorten, die bestimmte Qualitätsanfor-
derungen erfüllen. Wenn Sie dieses Heft in
die Hand nehmen, dann können Sie die Viel-
falt der Qualität begreifen und Sie können
sich informieren, was steckt dahinter, wenn
jemand 05572 | 1770 wählt.

Peter Felder Telefonseelsorge book A short-cut cover of this annual report from an Austrian charitable organization allows an entire suite of very different papers to peek out, symbolic of the many ways the organization helps people. As the reader leafs through the book, he or she sees that printing is restricted to the left page in each spread, leaving the right page—a different paper color and stock each time—to serve as a kind of art.

CUT PAPER

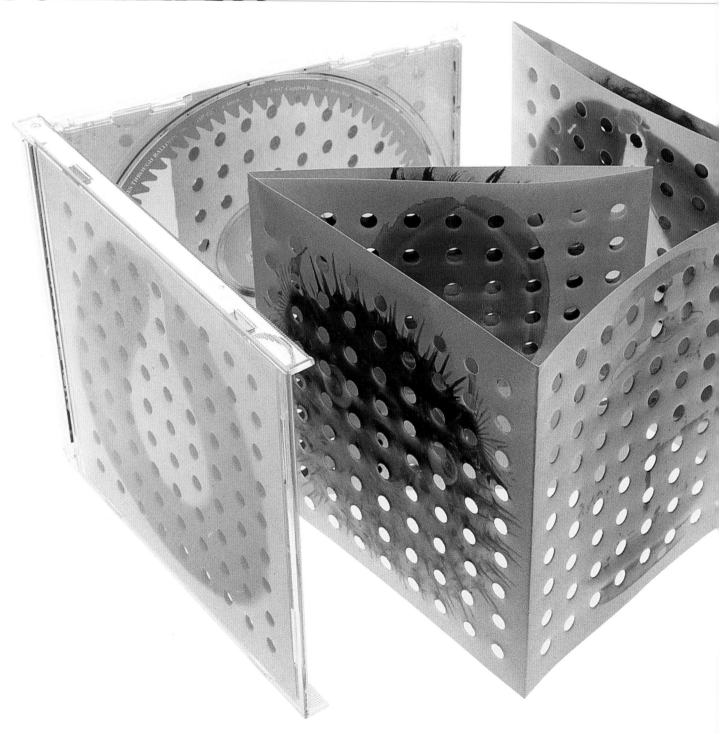

Cutting paper—one of the first things we learn to do in kindergarten. The ability to reshape paper into forms that we imagine—paper Valentines, paper dolls, snowflakes—is an early lesson in spatial relations that graphic designers never forget. In fact, the work featured in this section documents that the lesson goes on.

Some designs that follow are extremely intricate, laser-cut creations. Some were completed with a common paper punch or a pair of pinking shears. In between are designs that are drilled, punched, trimmed, perfed, and even torn. All take advantage of paper's extreme malleability.

Cutting can create actual design elements in a printed piece, as Hornall Anderson Design Works did when it punched an *X* all the way through a client's capabilities brochure. Cutting also can create texture: Several designs, including Miriello Grafico's stationery system, use perfing and subsequent ripping to create a tactile element simply not possible with an uncut paper design.

As designers have pushed the design limits of paper cutting, printers respond to the challenge by providing greater ranges of services for finishing paper. Many printers keep complete libraries of dies and drills that designers can use without the cost of creating a new cutting tool. Printers have also become invaluable in terms of advising how much abuse the paper can withstand.

But take away talk of cutting tolerances, lasers, and punch weight, and you get back to a designer, sitting at his or her desk with scissors in hand and a concept about to take shape on paper.

Sagmeister Songs of Maybe CD booklet (p. 92)
Paper: 100 lb. coated text

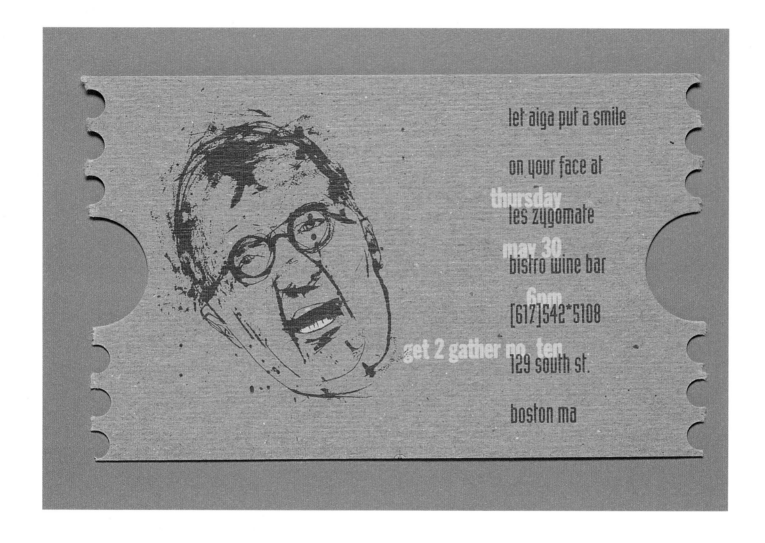

let aiga put a smile

on your face at

thursday
les zygomate

may 30
bistro wine bar

6pm
[617]542*5108

get 2 gather no. ten
129 south st.

boston ma

DESIGN FIRM blackcoffee design
DESIGNERS Mark Gallagher, Laura Savard
ILLUSTRATOR Mark Gallagher
PAPER Chipboard

blackcoffee design AIGA ticket invitation An incredibly oversized perforation makes this AIGA event ticket much more memorable than a standard postcard. Created by blackcoffee design, the torn-ticket invitation was perfed with punches that were placed in-line as the piece was printed letterpress. Because the cards were mailed, the designers needed to control the amount of the tear: The punches allowed them to achieve the look they wanted while meeting postal regulations. An additional plus: The cost per unit was very low, given its use of chipboard stock and punches already on hand at the printer.

blackcoffee holiday card An intricate mix of trims and folds make this combination invitation/holiday greeting card unique. A duplex stock plus a sticker created the appearance of a three-color design; all information on the card was printed onto labels and applied to the cut-and-folded designs. The Christmas-tree cut was developed as a design element and closure device. Designers Mark Gallagher and Laura Savard say they enjoy the challenge of pushing a medium like paper. It forces them to come up with new solutions that meet everybody's budgets.

DESIGN FIRM blackcoffee design
DESIGNERS Mark Gallagher, Laura Savard
PAPER Neenah Classic Columns, Red Pepper/Stucco Duplex 120 lb.

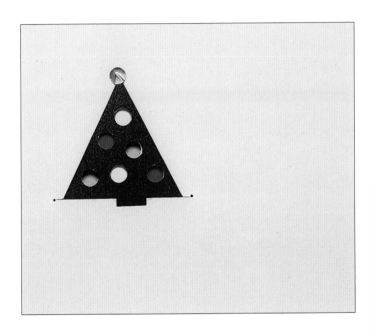

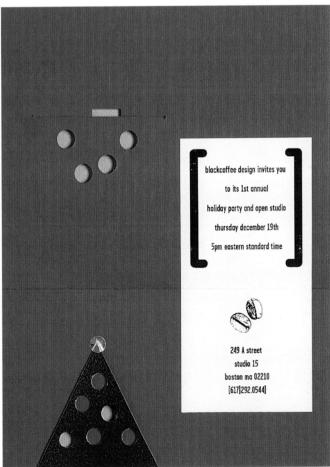

blackcoffee design invites you
to its 1st annual
holiday party and open studio
thursday december 19th
5pm eastern standard time

249 A street
studio 15
boston ma 02210
[617]292.0544

Michael Bartalos Recoleta String Quartet illustration Recoleta String Quartet is a personal piece created by illustrator Michael Bartalos, inspired by a trip to the celebrated Recoleta Cemetery in Buenos Aires. The artwork was created using various bits and scraps left over from other assignments, everything from textured Japanese handmades to domestic uncoated stock. The shapes were cut and pasted spontaneously without tracing, which led to unexpected but entirely exciting results.

ILLUSTRATOR Michael Bartalos
PAPER Various

Caroline Banks 307 Upland Road London SE22 ODL 081 693 7385

@KA Caroline Banks stationery Albert Kueh's design problem was identical to that faced by nearly every

designer: How could he project a memorable identity for his client through stationery with only one color? His

solution left the color dilemma behind. He asked textile designer Caroline Banks to use one of the more identi-

fiable tools of her trade — crimping (or pinking) shears — to trim off the upper right-hand corner. When folded

back and tucked through a die-cut slit, the now-tactile edge peeks through, turning the paper itself into art.

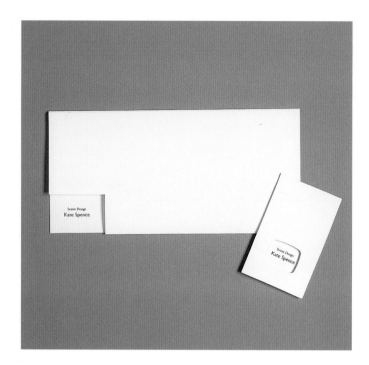

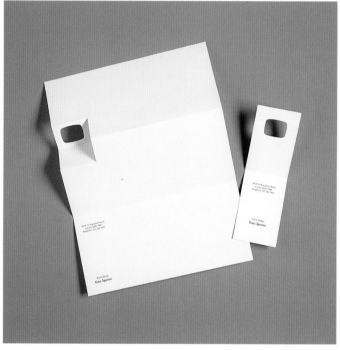

DESIGN FIRM @KA
DESIGNER Albert Kueh
PAPER Mellotex Smooth

@KA Kate Spence stationery Creating stationery for a set designer who specializes in television work required Albert Kueh of @KA to dream up a truly mixed-media solution. When folded in thirds for mailing, his client's name is neatly framed by a die-cut. When the sheet is unfolded, the same die-cut and a fold form a three-dimensional screen/stage to symbolize the client's work. The accompanying business card also uses the screen motif, and it too remains cleverly, subtly monochromatic.

@KA vampire party invitation In need of a "budget invitation for an interesting party," designer Albert Kueh turned to in-office tools to manifest his concept. After printing a piece of copyright-free art in the inside center of a folded card, he used a hand-punch on the folded spine of the card to make the telltale signs of a vampire (the theme of the party) on the visible image. Then he smudged the unfortunate girl's throat with office-inkpad blood.

Our Master Tee is celebrating his
30th Century
Come and sink your teeth this 24th May
Ceremony begins at four hours before
the stroke of midnight
Search for his Castle at
Nine Chesilton Road SW6 5AA

Butler may refuse entry to guest who
are not dress appropriately

Be warn that you come at
your on risk and may seriously
damage your health.

R.S.V.P. 0171 610 6376

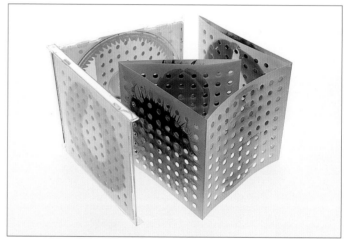

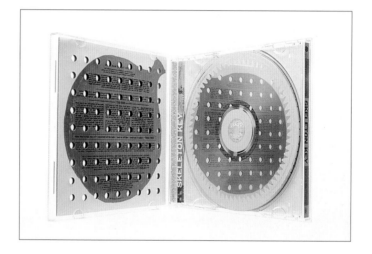

DESIGN FIRM Sagmeister Inc.
DESIGNER Stefan Sagmeister
PHOTOGRAPHER Tom Schierlitz
PAPER 100 lb. coated text

Sagmeister Inc. Songs of Maybe CD booklet True to this album's title, *Fantastic Spikes through Balloon*, designers at Sagmeister, Inc. photographed all of the balloon-like objects they could think of (sausage, whoopee cushion, blowfish, and so on) and punched holes through the entire CD book and all of the images. Because the band did not want their audience to read the lyrics (Sagmeister said that the band insisted, "This is not a poetry affair"), the lyrics are printed backward so they can be read only when reflected in the CD's mirrored surface (if even then).

Mark Russell Associates bag of lunch Once they developed the concept of using a bag lunch as a leave-behind for a food-bank fundraiser, it was up to MRA (Mark Russell Associates) designers to pack a meal that delivered visual appeal and good information. Their solution was to cut food shapes out of various paper shades, each carefully selected to match the food it represented. All printing and cutting was done in MRA's offices, paper stock was donated, and the bags were purchased at a discount to keep the cost of the promo down.

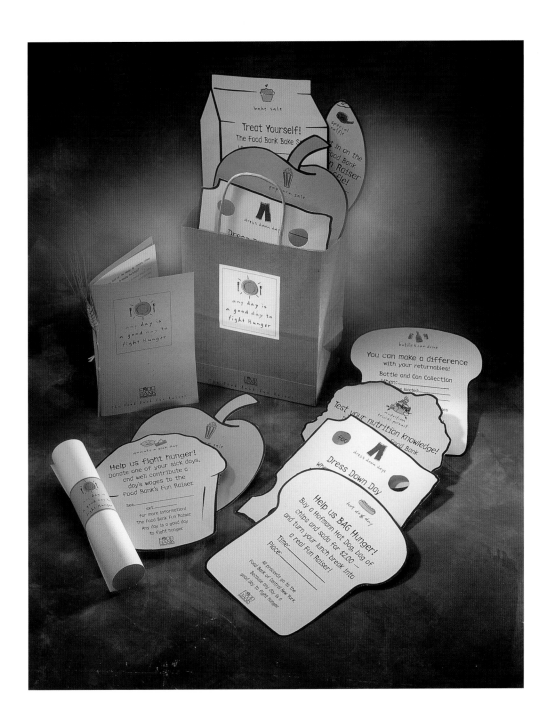

Mires Design wildlife brochure | Mires Design's concept for an exhibition catalog for animal-inspired artwork truly dots the *i*'s of the cover design. The dots over both letter *i*'s in the title are die-cut to let red show through from underneath. The effect evokes a wild animal's eyes glowing in the darkness.

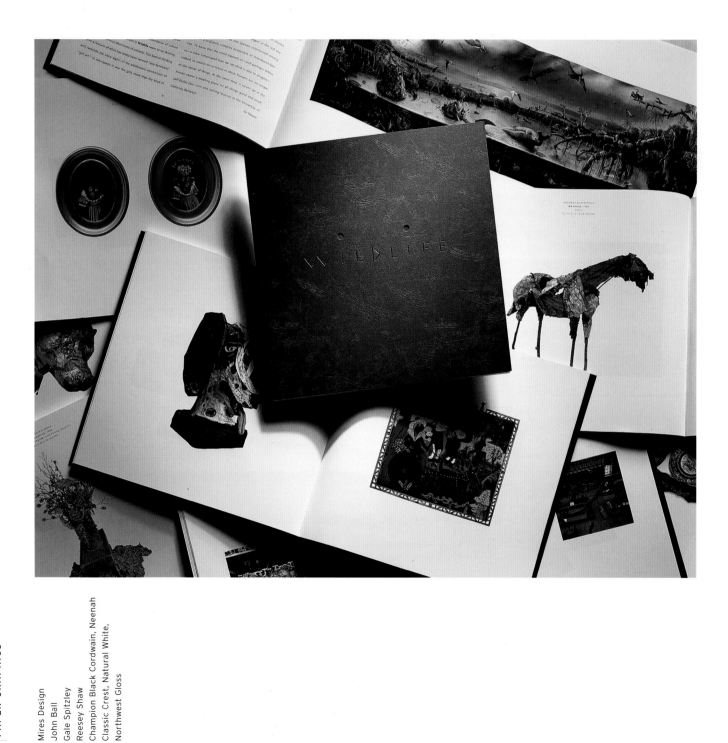

DESIGN FIRM Mires Design
ART DIRECTOR John Ball
DESIGNER Gale Spitzley
COPYWRITER Reesey Shaw
PAPER Champion Black Cordwain, Neenah Classic Crest, Natural White, Northwest Gloss

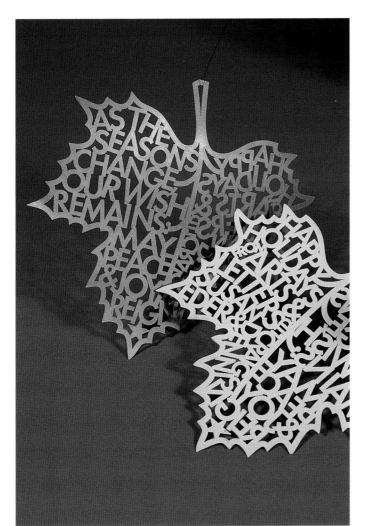

Arts & Letters, Ltd. **DESIGN FIRM**
Susan Eder **ART DIRECTOR**
Craig Dennis **DESIGNER**
Susan Eder (for "Wild") **CALLIGRAPHER**
Neenah Environment 80 lb. Cover, Geranium **PAPER**
Wove ("Wild"); Appleton Currency 80lb. Cover,
Copper/White

Arts & Letters Wild and Wondrous card and leaf card Each year, Susan Eder and Craig Dennis, partners in

Arts & Letters Ltd., create combination greetings/ornaments for their clients and friends. They have used

many different media for their unusual designs, but often they use paper. These two examples are laser cut, a

process Eder says has limitations and benefits. Though incredibly intricate cuts are possible, she notes that all

elements in the piece must be connected. Eder creates the design she wants first, then adjusts the design to

accommodate the process.

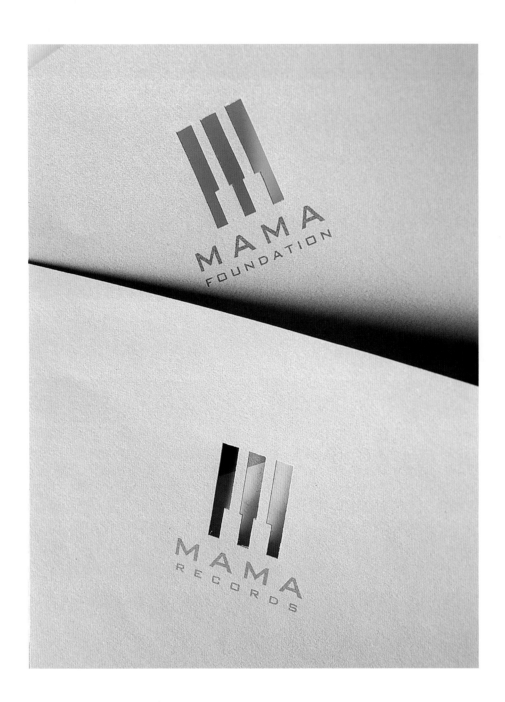

DESIGN FIRM Vrontikis Design Office
ART DIRECTOR Petrula Vrontikis
DESIGNER Kim Sage
PRINTER Donahue Printing
COPYWRITER Jodie Hauber
PAPER Champion Benefit 70 lb.

Vrontikis MAMA identity MAMA Records and the MAMA Foundation, a jazz-record label and foundation that supports jazz artists, wanted an identity that was simple, clear, and timeless. Designers at Vrontikis Design Office devised a musically appropriate logo, creating a die-cut mark in the shape of piano keys that also form an *M*. Specifying slightly different shades of the same stock helps users and recipients distinguish the two sheets. The die-cut was simple enough that special or heavy stock was not necessary: Petrula Vrontikis says that most 70-pound weights would work. She chose this particular stock for its colors.

Miriello stationery system When Miriello Grafico created its own stationery system, it wanted recipients to value the pieces and have the items themselves communicate for the firm. Endurance was also a consideration. The studio's solution is a tactile combination of papers and die-cutting. The perfed-edge treatment on some of the pieces was created with a 1930s handheld perforator and on other pieces with a letter-perfing punch, which Ron Miriello discovered in Italy where, he believes, they are used for passports and wine labels.

Miriello Grafico **DESIGN FIRM**
Ron Miriello **ART DIRECTOR**
Ron Miriello **DESIGNER**
Dean Amstutz **PRODUCTION**
Gilbert Esse, various colors **PAPER**

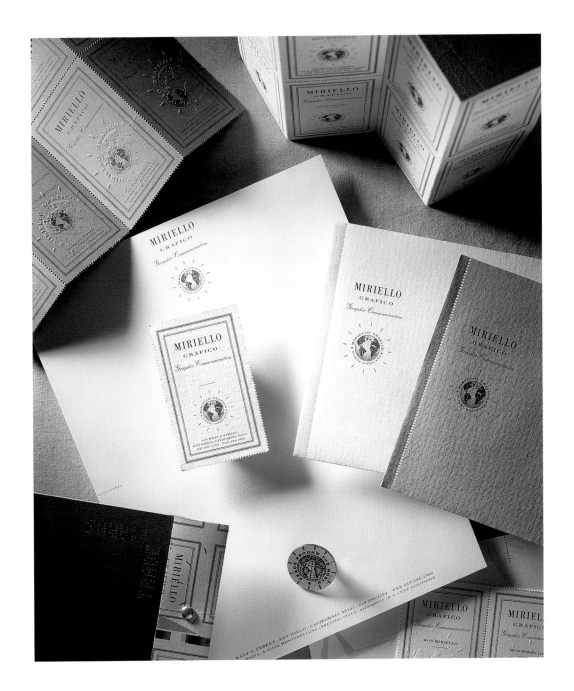

Hornall Anderson NextLink brochure A die-cut on a publication cover is nothing unusual. However, a die-cut that punches through an entire book is something altogether unforgettable. For its client NextLink (a fiber-optic phone company), Hornall Anderson Design Works worked the *X* for which the company has become known into the design of the cover and all inside pages as well. Pages were designed so that if slight misregistration occurred, no text or other crucial information would be obliterated by the die-cut.

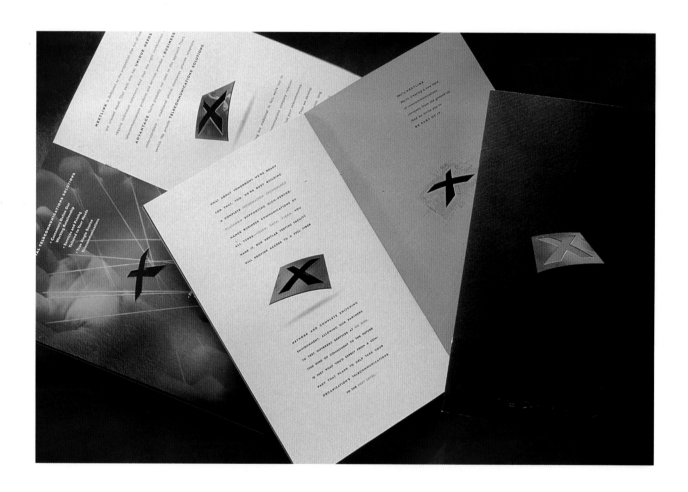

DESIGN FIRM Hornall Anderson Design Works
ART DIRECTOR Jack Anderson
DESIGNERS Jack Anderson, Mary Hermes,
Mary Chin Hutchison, David Bates
ILLUSTRATOR Yutaka Sasaki
PHOTOGRAPHER Tom Collicott
PAPER Champion Benefit (cover), Starwhite
Vicksburg (inside)

VeldsVorm Propaganda Communication Consultants Propaganda Inc. offers professional communications support and organizes events for other companies. Its Communication Consultants brochure detailed only one part of its offerings, and it was part of the launch of its new identity. Designers at VeldsVorm created an unbeatable new presence: The cover of the brochure is blanked out by a triangle, which plays an important role in Propaganda's new identity. This shape, according to the client's mission statement, represents a beam of light that singles out projects clearly. The styling of the interior matches this with illustrations that mimic the triangle, printed on full pages.

DESIGN FIRM VeldsVorm Design & Consultancy
DESIGNERS Stephan van de Kimmenade, Marc Koppen
ARTWORK Rik Hoving
PRINTER Van den Berg's drukkerij
PAPER Memoires de paper bicolore 250 g (cover), Biotop, Canson Satin Transparent (wrapper and interior)

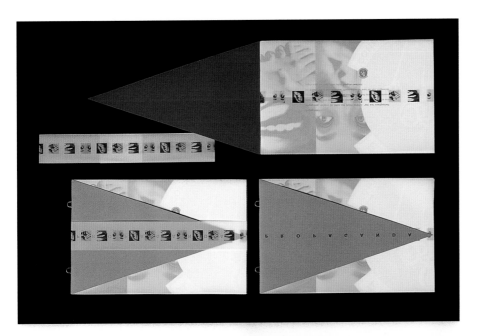

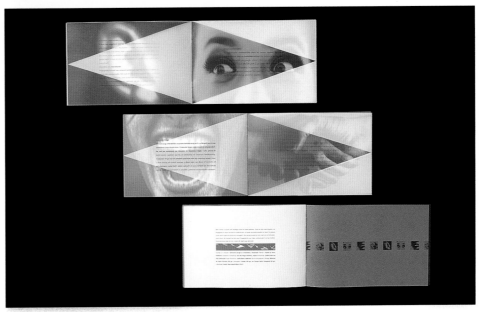

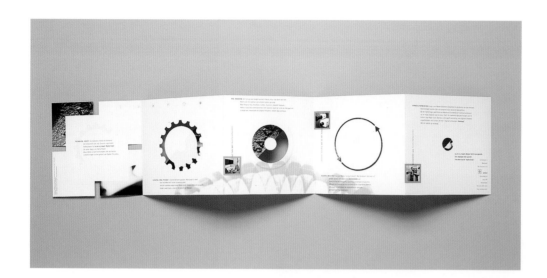

DESIGN FIRM VeldsVorm Design & Consultancy
DESIGNERS Bart op het Veld, Stephan van de Kimmenade, Marc Koppen
ARTWORK Rik Hoving
PRINTER Drukkerij Johan Enschede
PAPER Mohigliani Insize, Alpha paper

VeldsVorm Mahez invitation | Mahez supplies a wide range of products for the graphics industry, and it plays a large role in the development of new technology. The firm's drive to turn the theory of the future into the practice of today was one reason why it asked VeldsVorm Design & Consultancy to shape this invitation to an open house into an innovative print piece. VeldsVorm designers created a die-cutter's dream: Each of the invitation's Z-fold pages carries a different cut, some of which seem to float cut-out objects in midair. The entire piece is slipped inside a half sleeve.

VeldsVorm Kinderziekenhuis book Wilhelmina Kinderziekenhuis is a children's hospital in the Netherlands. Its logo represents a children's jigsaw puzzle. This image, together with children's handwriting and bright primary colors, are the central points of the hospital's identity. When creating a sponsorship brochure for the organization, VeldsVorm Design & Consultancy placed a die-cut interpretation of the logo on the cover: The recipient gets a peek at the people helped at the hospital.

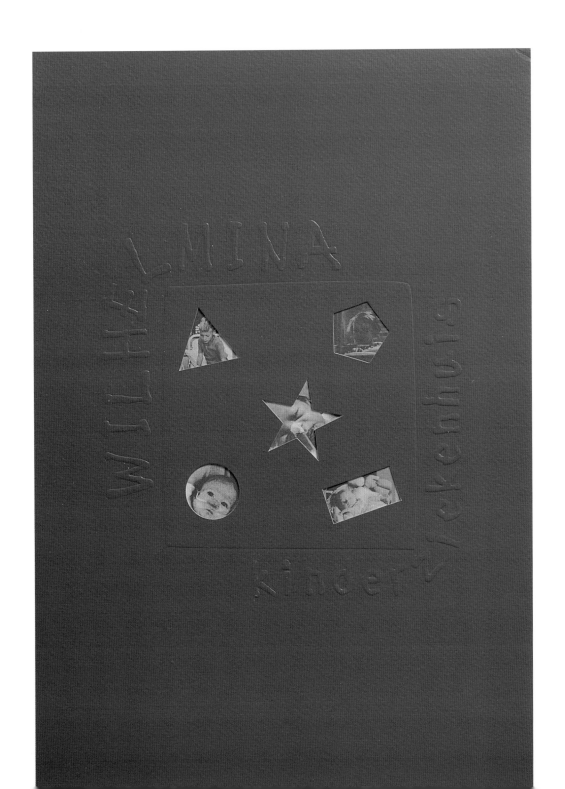

DESIGN FIRM VeldsVorm Design & Consultancy
DESIGNERS Bart op het Veld, Stephan van de Kimmenade
ARTWORK Stephan van de Kimmenade, Rik Hoving
PRINTER Van den Berg's drukkerij
PAPER Dahli insize, Artic Volume, Alpha paper

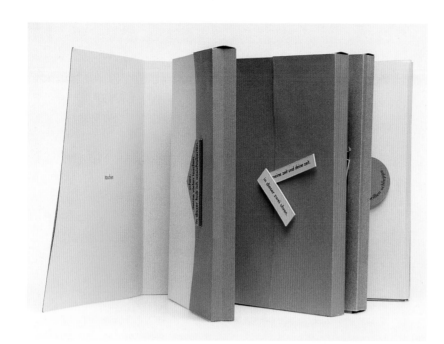

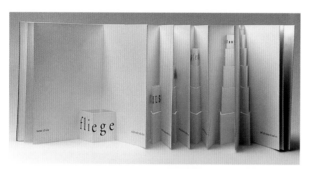

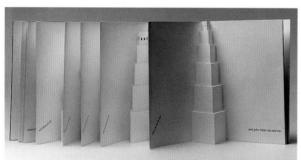

DESIGNER Babsi Daum
PAPER Various

Babsi Daum Gedichtbuch booklets Babsi Daum is a fine artist who focuses her work on books and paper.

She enjoys converting a literary work's meaning into a paper interpretation. For a collection of poems by Ernst

Jandl, Daum created a limited edition of handmade books. Each book contained nine separate portfolios, each

containing a single poem displayed in graphic form. Daum says she wanted to convey the same emotions the

poet expresses when he reads his own work.

Bailey Lauerman holiday card Each year, Bailey Lauerman & Associates produces a holiday greeting card to mail to its clients, associates, and friends. With heightened concern about political correctness, they decided that they could best extend appropriate and heartfelt wishes to everyone by letting recipients create their own message. The extremely simple, one-color card was humorous and a great success: Its interactive nature caused many to call it the best holiday card they had every received.

Bailey Lauerman & Associates **DESIGN FIRM**
Marty Amsler **ART DIRECTOR**
Rich Bailey **CREATIVE DIRECTOR**
Nick Main **PRODUCER**
Nick Main **COPYWRITER**
Vintage Gloss Cover 120 lb. **PAPER**

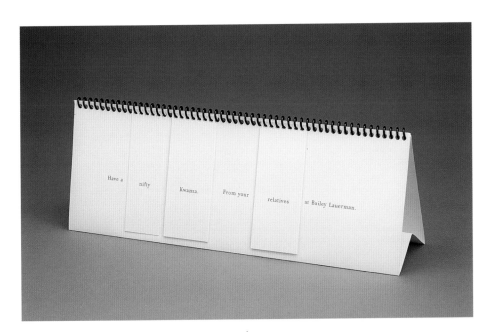

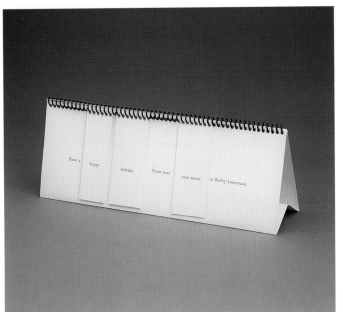

Bailey Lauerman Pacific Realty peek-a-boo book Bailey Lauerman's client, Pacific Realty, wanted a brochure that represented its unique position in the marketplace and that communicated the high level of services it offers to clients. The design firm responded with a peek-a-boo book that was unlike anything offered by Pacific Realty's competitors: Every spread includes a flap that flips up to reveal conceptual illustrations that relate to the text on the opposite page.

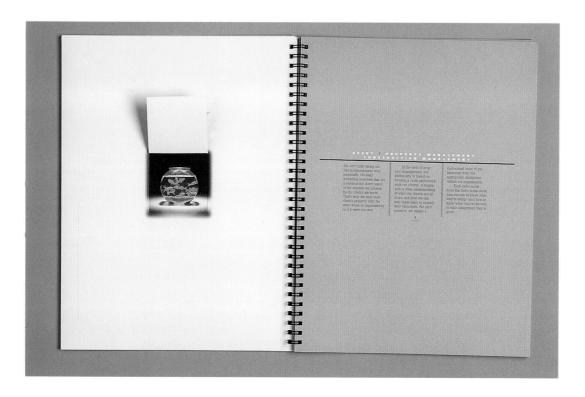

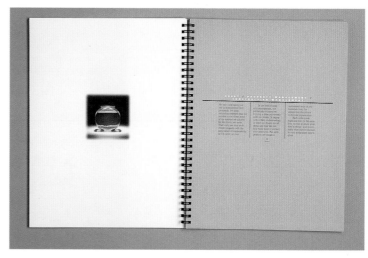

DESIGN FIRM Bailey Lauerman & Associates
CREATIVE DIRECTOR Carter Weitz
COPYWRITER Laura Crawford Piper
PRODUCER Laura Crawford Piper
PAPER French Construction Cover 80 lb.

heartport

1996 ANNUAL REPORT

Cahan & Associates **DESIGN FIRM**
Bill Cahan **ART DIRECTOR**
Craig Bailey **DESIGNER**
Ken Schles, Tony Stromberg, William McLeod **PHOTOGRAPHERS**
Cougar 80 lb. White (cover) **PAPER**

Cahan Heartport annual report The difference between traditional, traumatic open-heart surgery and the minimally invasive, two-hole process developed by Heartport is the theme of its 1996 annual report. Designers at Cahan & Associates had two holes drilled all the way through the 10 1/2-by-13 3/4-inch, hardcover book. The holes duplicate exactly the size of incisions used in Heartport's procedure, dramatically demonstrating the technology. Each inside page accommodates the holes in its design.

DESIGN FIRM Visual Dialogue
ART DIRECTOR Fritz Klaetke
DESIGNER Fritz Klaetke
TYPOGRAPHY Frank Klaetke
PRINTER Alpha Press
PAPER Strathmore Writing Text, Strathmore
Writing label stock

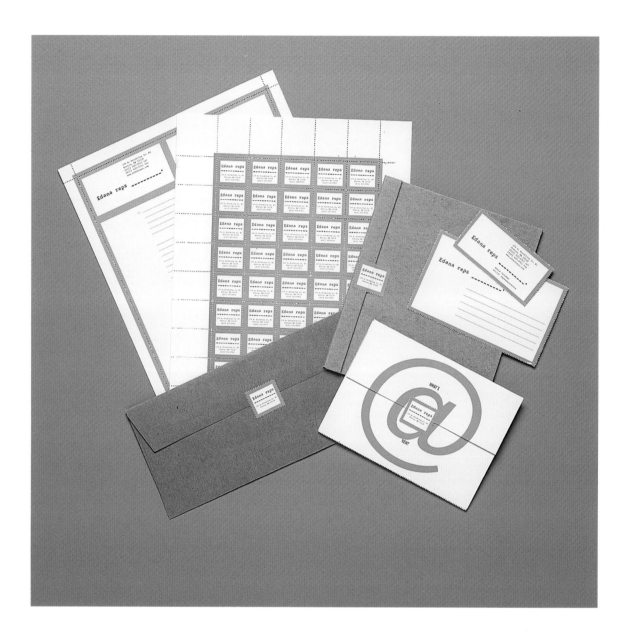

Visual Dialogue Edana Reps identity Edana Reps, an artist's representation firm, wanted to present a flexible, hard-working, resourceful image. Toward that end, designers at Visual Dialogue combined rubber stamps, stickers, and pinhole-perfs to present a utilitarian, unfussy identity. Typewriter type and a muted two-color palette, combined with buff and brown kraft papers, complete the look.

Messinastrasse 13

FL-9495 Triesen

TEL 075-390 09 30

FAX 075-390 09 31

ISDN 075-390 09 32

karin.beck@karinbeck.li

Karin Beck ANSTALT

Grafische Gestaltung

Karin Beck GESCHÄFTSFÜHRERIN

Karin Beck business card | Designer Karin Beck perfed her own stationery system primarily because she likes the effect, but also because she wanted recipients to see as well as touch the components. The design, she says, had to be very simple and elegant, just an understatement. The oval shape around her company name highlights the main information, and it expresses the wide and open movement of ideas.

Babsi Daum Terzinen book Poet Franz Josef Czernin's poem "Terzinen" is written in triplets and can be read in numerous ways by reordering the pieces. Artist Babsi Daum set out to replicate the same effect in a book. The result is a limited-edition book with flaps that can be open and shut to reorder the poem. Daum's graphics also change as the pages are turned.

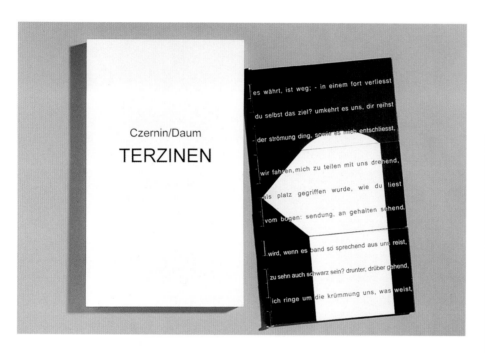

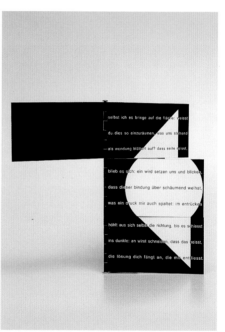

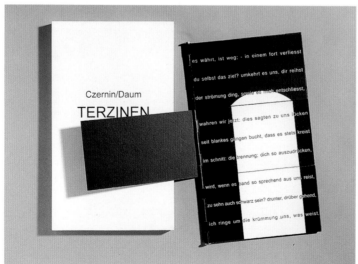

DESIGN FIRM Babsi Daum
PAPER Various

Cross Colours Ink **DESIGN FIRM**
Janine Rech, Joanina Pastoll **CREATIVE DIRECTORS**
Janine Rech **DESIGNER**
Janine Rech **ILLUSTRATOR**
Magno Matte 300 gsm **PAPER**

CUT PAPER | **109**

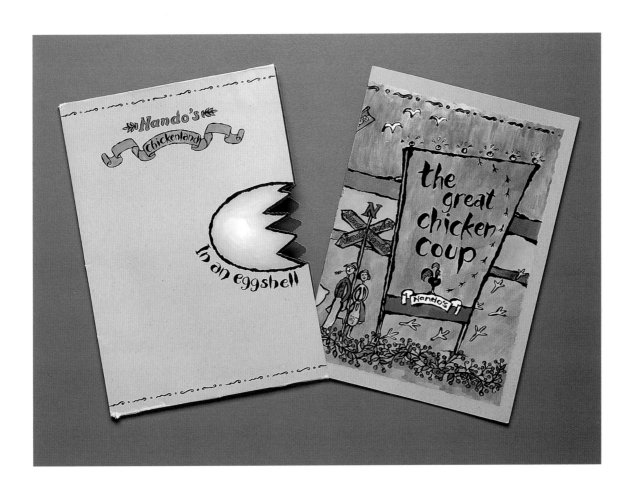

Cross Colours Nando eggshell folder | Cross Colours embedded in this brochure folder a sense of fun and humor that matches its client's personality. Nando's, known predominately for its chicken products, can appropriately be represented by an egg. Because this brochure, which folds out to a gatefolded poster, depicts a day in the life of Nando's, a die-cut broken-egg shape with its jagged edges pointing in the forward direction seemed an apt metaphor to convey the client's message.

ALTERNATE PAPER

Alternative stock, as defined today, is a misnomer. For most, the current definition of paper is a product made from wood fiber. But when paper was first invented, it was made from alternative materials: The first paper-like material, papyrus, was developed in ancient Egypt around 3000 BC, and the first actual paper was developed from rags in China in AD 105.

In the last decade, papers made from alternate sources have made a big comeback. Some designers have environmental reasons for specifying papers made from kenaf, cotton, banana fiber, tobacco by-products, recycled paper currency, grass clippings, garlic skins, hemp, corn husks, tea leaves, hops and recycled beer labels, recycled junk mail, seaweed, and even the chaff of roasted coffee beans. Others use these exotic sheets for purely conceptual means. Still others simply love their texture and color. (There may be others who like their smell: The grass and coffee papers are said to smell like a fresh-cut lawn and brewed java respectively when subjected to the heat of a laser printer.)

Some specialty papers have become even more specialized: Cotton is being grown not only in white but also in brown and sage green to create paper, cloth, and other products that do not require dyes.

Specifying an alternate paper can still be a risky proposition for various reasons. Some printers will not print on them, or they have little experience dealing with the peculiarities of such papers. While some papers are available in sufficient quantities for large design jobs, others are not. Paper shades or weights can change without warning. Some even cease to exist due to lack of demand.

But when you see the beautiful results achieved by Richardson or Richardson in a golf-course design booklet, or by Sigi Ramoser's molded-paper cards, you can see the potential in the out of the ordinary.

Enormous Egg handmade cards (p. 114)
Paper: Handmade plant-fiber

Matsumoto, Inc. Reorientations book A catalog for a fine-arts exhibition, Reorientations, has a cover made from an industrial-like grade of chipboard but uses the paper to suggest a very different sense—that of an aesthetic awareness emerging from Eastern culture. Designers at Matsumoto, Inc., could have used silk-screening, letterpress, hot stamping, or engraving to print the cover. They chose engraving (which the paper manufacturer actually warned against using) because it offered a richness the other processes did not. A screen was used to help the ink adhere better.

DESIGN FIRM Matsumoto, Inc.
ART DIRECTOR Takaaki Matsumoto
DESIGNER Takaaki Matsumoto
PAPER French Paper Packing Carton Cover
145 lb. (cover); Mohawk Superfine
(text pages); parchment (endsheets)

Vaughn Wedeen University of New Mexico design Handmade paper was used for this limited-edition design, created by Vaughn Wedeen Creative for the University of New Mexico Foundation. Twenty boxes were produced for targeted foundations in an effort to raise the money necessary to purchase the largest privately held collection of New Mexico santos. Handmade wooden boxes, hand-punched tin, ribbon, and jute combine to make an unforgettable package.

DESIGN FIRM Vaughn Wedeen Creative
ART DIRECTOR Rick Vaughn
DESIGNER Rick Vaughn
PHOTOGRAPHER Michael O'Shaughnessy
PAPER Handmade by Judy Hatfield (covers and cards); French Speckletone Old Green Text 70 lb. (text and tip-ons)

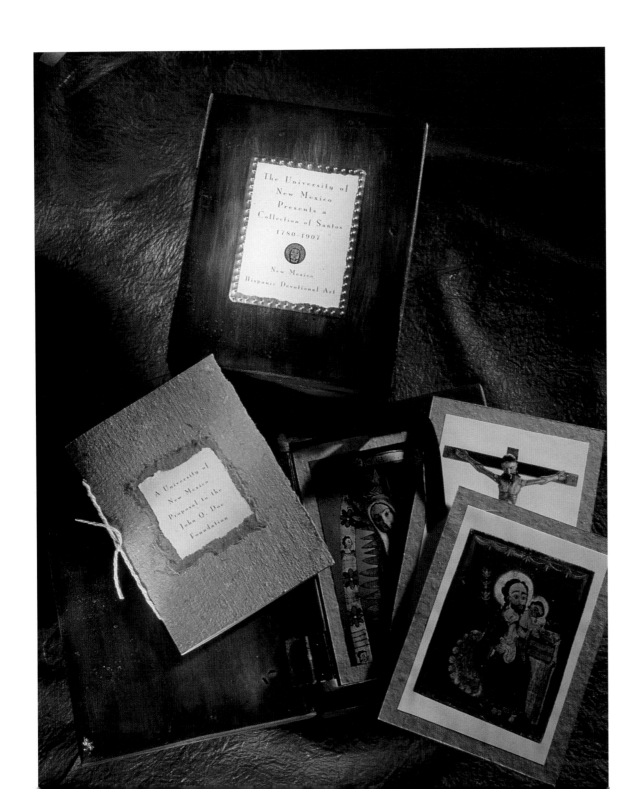

Enormous Egg handmade cards Debra Mulnick of Enormous Egg Designs collects papers of all kinds to create one-of-a-kind boxes and cards. Papers made from plants native to the area, including milkweed, sage, cedar bark, barley, and grass, appear frequently in her work. Boxes (not shown) are made from blank Japanese papers that Mulnick marbles (sometimes twice) and laminates with another contrasting colored paper for the liner. For bonding, she uses a heavyweight interfacing from a fabric store.

DESIGN FIRM Enormous Egg Designs
DESIGNER Debra Mulnick
PAPER Handmade

Vrontikus Design printer promotions For a series of printer promotions, Vrontikus Design Office decided

the best approach would be to design useful items that would be kept by recipients, mainly designers and art

directors. Floppy-disk holders, SyQuest covers, and decimal-conversion charts seemed like natural choices.

Other mailers are shown here as well. Vrontikus designers used stocks made from recycled currency, kenaf,

and hemp fibers. Principal Petrula Vrontikus enjoys working with alternate stocks (including papers made from

barley, hops, and seaweed) but notes that availability can vary.

DESIGN FIRM Vrontikus Design Office
ART DIRECTOR Petrula Vrontikus
DESIGNERS Petrula Vrontikus, Kim Sage, Christina Hsalo
PHOTOGRAPHER Don Miller
PAPER Crane's Old Money, Kenaf, Eco Paper Hemp

ALTERNATE PAPER 115

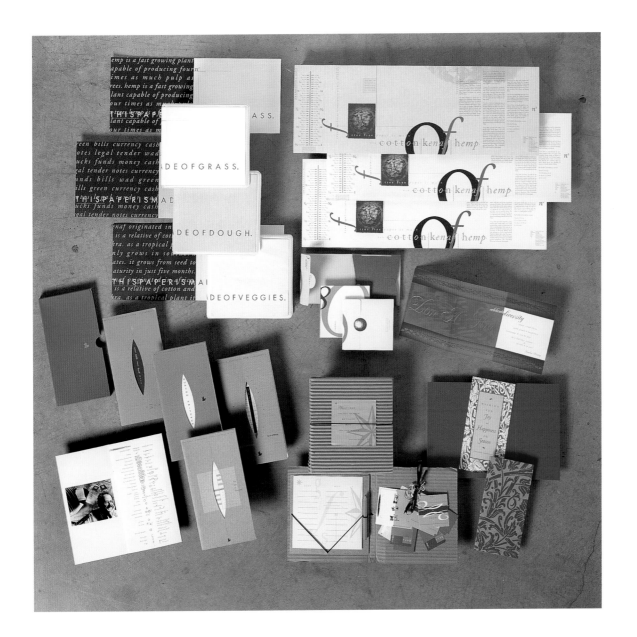

Louey/Rubino Protero folder Printed entirely on Protera, a Hopper grade stock, Louey/Rubino Design

Group created this organizer to serve as a presentation to designers on the variety of grade envelopes

available. A textured, handmade paper that would not behave well on press was scanned in four colors for

its surface texture and was printed as art to give the piece the look of an alternate stock.

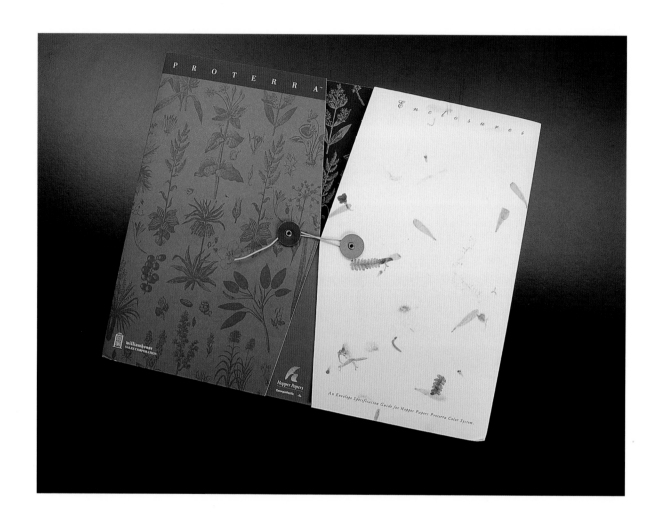

DESIGN FIRM Louey/Rubino Design Group
PAPER Hopper Protera

Richardson or Richardson golf course book Two very different substrates are used for this promotional booklet, created by Richardson or Richardson for a golf course architectural group. The first is a natural choice— conceptually and biologically— Golf Paper made with grass clippings taken from golf course greens. Occasionally, a small bug will even make its way into the paper. The type is letterpressed. The art blocks, though, are created by printing scanned art onto T-shirt transfer material that subsequently is hot-pressed onto muslin fabric. The newly created canvas is trimmed, adhesive is applied, and the square is affixed to a debossed panel on the page.

DESIGN FIRM Richardson or Richardson
DESIGNERS Forrest Richardson, Debi Mees
WRITER Forrest Richardson
PAPER Four Corners Golf Paper Sand Trap White 90 lb.

DESIGN FIRM Spielman Design

DESIGNER Amanda Bedard

PAPER Arches Cover (cover); Moulin Du Gue with deckle; Domestic handmade, Bits 'n Pieces; Thai Decorative Papers, Thai Gold; Japanese Decorative Papers XXII; Isago Foil

Spielman Design Continental-Anchor invitations Designer Amanda Bedard created this invitation series for Continental-Anchor to promote the range of interesting papers and high-end printing techniques that the client offers. In order to emphasize the beauty of the unusual papers, Bedard created little frames for the small sheets in the invitation covers and chose papers that helped convey the client's messages.

Mires Design Inc. **DESIGN FIRM**

John Ball **ART DIRECTOR**

John Ball, Miguel Perez **DESIGNERS**

Handmade (folder); Rising Drawing Bristol, **PAPER**
Four-ply vellum (card)

ALTERNATE PAPER | 119

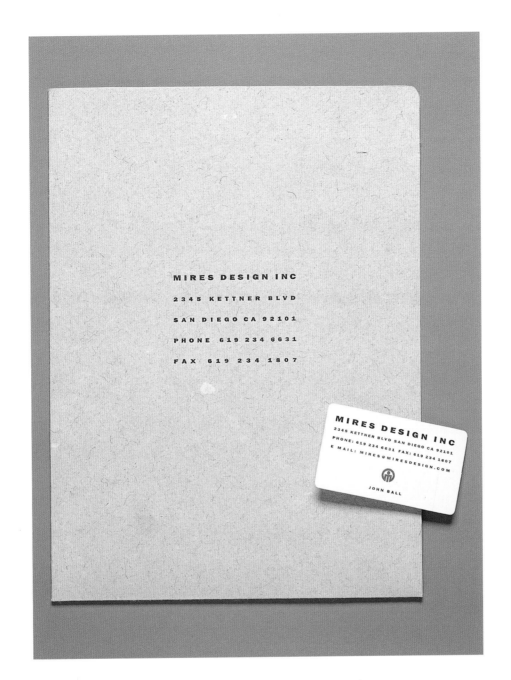

Mires Design folder and business card Mires Design's folder is made entirely from waste stock. Because the handmade paper is too thick for offset, the folders are blind embossed and then letterpress printed in one color. The design studio's business card has the same thick, solid feel—to convey the solid, hardworking philosophy the company likes to project—but it is made from Bristol board. Letterpressed in two colors, it has an embossed, tactile feel.

Hornall Anderson Mahlum name-change announcement When Hornall Anderson client Mahlum & Nordfors

MicKinley Gordon decided to change its name to just Mahlum, the architecture firm wanted to send out a

special-edition vehicle. Aiming for a handcrafted look, the designers gave the announcement cards a textured

outer wrap and closed the packages with an elegant paper seal. The mailer was shipped in a transparent vellum

packet, stitched on its edges with dark thread.

DESIGN FIRM Hornall Anderson Design Works
ART DIRECTOR Jack Anderson
DESIGNERS Jack Anderson, Heidi Favour, Bruce Branson-Meyer, Mary Hermes
ILLUSTRATOR Mahlum
PHOTOGRAPHER Various
COPYWRITER Pamela Mason Davey
PAPER Strathmore Beau Brilliant, Palm Beach White 130 lb. (cards); Tai Chiri (outer wrap); Gmund Boch (sticker); Gilclear Medium Cover (envelope)

Sixth Street Press **DESIGN FIRM**
Sharon M. Young **AUTHOR**
Donna C. Locat **ILLUSTRATOR**
KP Products Vision Paper **PAPER**

ALTERNATE PAPER 121

Sixth Street Press *Abundant Harvest* **book** Publisher Sharon Young's reason for specifying kenaf paper for

Abundant Harvest: Scenes, Stories and Recipes from Fresno's Vineyard Farmer's Market was symbolic: Kenaf

paper is made from the kinds of plants that could be grown by the people featured in the book. Since the book

is about sustainable agriculture, reasoned Young, it made sense to use paper produced from a rapidly growing

plant that yields four times the amount of paper per acre than trees. Incidentally, the paper's soft tone mimics

watercolor paper, an appropriate vehicle for the book's sketchbook-like illustrations.

Jeanette Hodge Sarah Mann dance brochure | This Sarah Mann dance brochure is small—just 5 by 7 inches. The designer chose newsprint for the brochure because the paper is fragile: immediate, temporary, and ephemeral as a dance performance. A coarse screen of the images and the newsprint paper make the visual more interesting texturally—and helped hide flaws in the photography.

DESIGN FIRM Jeanette Hodge Design
PAPER Newsprint

Jeanette Hodge brunch postcard Jeanette Hodge used 100 percent cotton paper for this restaurant

brunch postcard partially for environmental reasons. But she also liked the way it reflected the simplicity

and tactile quality of the establishment's food and its environment. For an even more interesting surface,

Hodge used handmade rather than machine-made cotton paper.

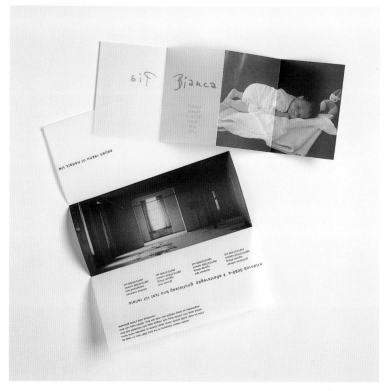

DESIGN FIRM Sigi Ramoser
PAPER Zanders Reflex Hochtransparent 200 gsm and 110 gsm

Sigi Ramoser transparent cards Designer Sigi Ramoser loves to experiment with transparent stock: It offers a design tool with different levels, and the designer can overlay text to picture for interesting effects. This technique can offer several different reading or viewing experiences from a single design, as this birth announcement and capabilities brochure demonstrate.

Sigi Ramoser molded paper cards | Vorarlberger Papierfachgeschäft translates in English as *paper specialty shop of the country Vorarlberg,* where the designer of this card lives. Hand-scooped cotton paper pulp was laid out, and objects were pressed into it. The goal: to communicate that the shop was selling freshly scooped paper.

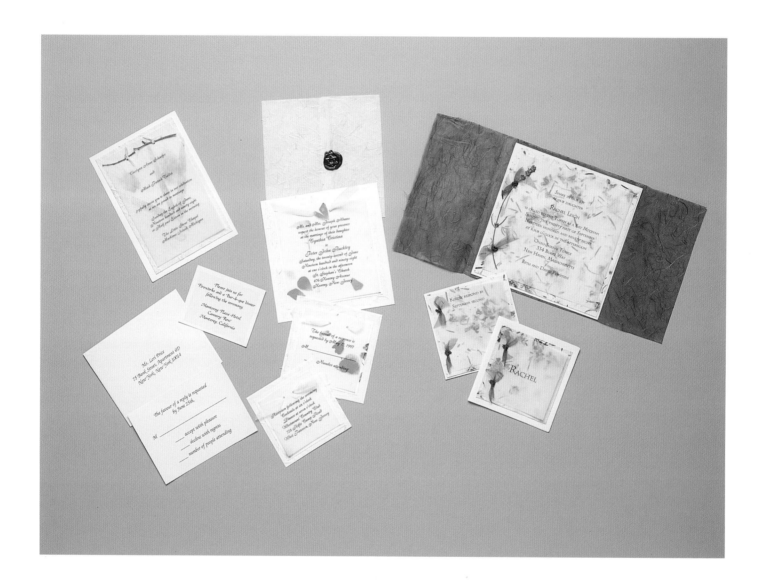

126 PAPER GRAPHICS

DESIGN FIRM Woodson Creative
DESIGNER Laurel Shippert
PAPER *Bat mitzvah:* Arches Cover
100 percent cotton; Zina Papers
Larkspur Handmade; Glamma
Natural Vellum.
Adams wedding: Hopper Feltweave;
Kinwashi rice paper; Rose and Grass
over; Glamma Natural Vellum.
Schaefer wedding: Arches Cover
100 percent cotton; Thai Garden
Paper; Kinwashi rice paper;
Mediovalis envelope

Woodson Creative invitations Laurel Shippert's clients come to her expecting to have alternative papers

used in their designs. Brides, bar and bat mitzvah candidates, and other happy celebrants want to convey their

excitement to invitees. Shippert hunts down and incorporates rose, grass, rice, cotton, and many other sorts of

paper in her creations. The designer ignores what others are doing with exotic papers; instead, she gathers

lots of samples and simply starts mixing and matching.

DESIGN FIRM Bull Rodger
DESIGNERS Jos Cook, Nial Harrington
COPYWRITER Paul Rodger
PAPER 150 gsm tracing paper with; art end papers

OUR APPROACH is based on a deceptively simple formula. We combine a flexible design process with a practical, working knowledge of building techniques and crafts, believing firmly that the most creative solutions in the world are of little value unless they can be translated into a workable reality. We also understand that attention to detail can make all the difference between an acceptable result and an exceptional one.

Bull Rodger Allman Associates booklet Bull Rodger's brochure design, done for a small interior-design consultancy, is printed on a basic tool of the interior design trade, tracing paper. Six-color screen printing allowed the designers to use opaque inks. A graphic collage of interior design elements is revealed as the book is opened; as each page is turned, pieces of the collage are peeled away.

PRINTED PAPER

PUT THE PEDAL TO THE METAL

It used to be that designers were the ones who pushed paper to achieve formerly unheard-of results. Now that many printers have gotten into the act, partnering with designers, nothing seems impossible.

This section is longer than others found in this book, and it could have been twice again as long: Embossing, stamping, thermography, letterpress, finely tuned offset printing, and more are used to dress up paper in unbelievable ways. Printers' libraries of dies and strikes are much larger, cutting a designer's cost if he or she can use an existing shape. Hundreds of stamping colors and foils are available. Letterpress is enjoying a popularity revival both among designers and the public.

Effects can be subtle, like Amanda Bedard's delicately embossed Berger + Partner stationery design. They can be bold but still understated; see Lippa Pearce's D & AD booklet cover. Or they can be unapologetically in-your-face, like Independent Project Press' work, several samples of which are included in this section.

Designers are even abandoning traditional production techniques altogether, as in the blue-print-printed and just plain ripped samples that follow. In terms of creativity, the newest graphic design work is steadily raising the bar higher and higher.

Vaughn Wedeen Pedal to the Metal book (p. 143)
Paper: Kraft chipboard (cover), Vintage Velvet Cream Cover (interior)

Karin Beck Propter Homines stationery Propter Homines is a foundation that supports social and cultural projects and institutions; its name translates to *for the people*. Karin Beck used the image of a hand, embossed beneath the organization's name, to graphically represent giving. She chose the creamy paper and green ink to give the design warmth and "a sense of preciousness."

130 PAPER GRAPHICS

DESIGN FIRM Karin Beck, Grafische Gestaltung
ART DIRECTOR Karin Beck
DESIGNER Karin Beck
PAPER Arjo Wiggins Rives Classic 90 gsm

Karin Beck, Grafische Gestaltung **DESIGN FIRM**
Karin Beck **ART DIRECTOR**
Karin Beck, Connie Kaufmann **DESIGNERS**
Not available **PAPER**

PRINTED PAPER 131

Karin Beck Berger + Partner stationery | Berger + Partner Bureau for Architecture needed a stationery system that expressed the three-dimensional nature of its work. Designer Karin Beck's solution was to place the words *berger* and *partner* on horizontal and vertical axes. The plus sign was transformed into a sculpted emboss, which added a third dimension to the design.

BLACKCOFFEE DESIGN

Mark Gallagher

249 A St Studio 15
BOSTON MA. 02210
PH: [617] 292.0544
FX: [617] 292.4732

DESIGN FIRM blackcoffee design
DESIGNERS Laura Savard, Mark Gallagher
PAPER French Packing Carton 145 lb. cover

blackcoffee design business card | The blackcoffee business card is decidedly unique. First is its size—3 1/2 by 1 1/4 inches. Second, it is printed on chipboard. Third, and probably most notable, it uses a clear overprinting usually reserved for printing on T-shirts. The card's graphics are printed on a vinyl heat-transfer sheet that subsequently is heat-pressed onto the chipboard. The result is a tactile coating that brings the dull stock to life. Though the cards are costly, blackcoffee designers say they have brought in plenty of new clients.

Troller Associates exhibition catalog cover A person's signature is a significant documentation of his or her character, designer Fred Troller says. For the cover of an art exhibition catalog, then, he used the signatures of featured artists as illustrations. The glossy silver foil stamps alternately shine and turn black against the rough, earthy cover, depending on how the book is held. The cover becomes animated and alive, like the work of the artists shown in the catalog.

Louey/Rubino Fremont General report | Normally, when a designer or client springs for an embossing die, he or she uses it in a big way—even on several different pieces—to amortize its cost. Louey/Rubino Design Group's design for Fremont General's annual report takes a different tack: An extremely subtle die was used on two pages of the report. The lines in the strike pick up every nuance of a hand-drawn line, which gives the delicate blind emboss another layer of interest.

Market Knowledge. Superior knowledge of the geographic area within which a corporation engages in distributing its product or service is an absolute necessity if that company wishes to effectively operate within our dynamic global economy. The ability of an organization to identify not just a market, but a market opportunity, is a requisite for any organization attempting to advance a fundamental long range strategy. For it is such a company that will approach markets on an informed and intelligent basis, and thereby be expected to outperform its competitors, achieve long term stability, and enhance shareholder value.

In our effort to determine the degree to which we should be participating in any particular market, we look at several primary factors including the regional economy, the regulatory and judicial environment, competitive pressures, and saturation points. This particular insight allows the company to quickly recognize subtle market trends, and consequently, take appropriate action on a timely basis. Therefore, our basic objective is to remain competitive in our current markets, and responsive to potential new market opportunities.

The national expansion of our insurance operations over the last several years is the culmination of a thorough market analysis, with a particular focus on the competitive pressures in the California workers' compensation marketplace, and a comprehensive regulatory review. After this evaluation, it became clearly evident that long term growth and earnings stability would require expansion beyond our historic principal California marketplace. The strategic and timely acquisition of the Casualty Insurance Company immediately established Fremont as a force in the national workers' compensation marketplace, and at the same time gave the company the platform upon which to seize opportunities in various additional neighboring states. The secondary benefit of this marketplace evaluation and national expansion was the company's ability to take advantage of numerous operational efficiencies. By having the vision to expand our markets as we have evolved, Fremont General has become a better balanced organization by diluting product line and geographic concentrations.

Our ability to maximize shareholder value over the long term will be determined by our ability to quickly evaluate and expand into favorable markets, or conversely, to withdraw from deteriorating markets as conditions dictate. In each of our respective businesses, we have worked diligently to evaluate the markets in which we are engaged. We have demonstrated that our organization has both the requisite depth and capacity to continually anticipate market changes, and to respond with appropriate strategies to capture market opportunities.

DESIGN FIRM Louey/Rubino Design Group
PAPER Potlatch Karma; Gilbert Esse

Cahan & Associates Regarding Relationships Many venture capitalists are perceived as "vulture capitalists," only out for money. But Interwest Partners wanted to reinforces its reputation as one of the good guys in its new brochure. So instead of laundry-listing Interwest's credentials or numbers, Cahan & Associates emphasized the firm's ability to create and maintain relationships. Cahan designers created a diminutive 6 3/4-by-9 1/2-inch booklet, letterpress printed even on its cover, to offer a personal, intimate impression.

Cahan & Associates **DESIGN FIRM**
Kevin Roberson **DESIGNER**
Tim Bower **ILLUSTRATOR**
Tim Peters, Kevin Roberson **COPYWRITERS**
Starwhite Vicksburg 65 lb. (cover); **PAPER**
Starwhite Vicksburg Smooth 70 lb. (inside)

REGARDING

RELATIONSHIPS

INTERWEST PARTNERS

François Gervais transparent birth announcement Artist François Gervais used a parchment-like paper

with a milky transparency to create this birth announcement for his daughter, Tess. By printing his brushy illus-

trations on one side of the sheet and his calligraphic text on the other, Gervais produced a mysterious, story-

book effect to announce the baby's arrival.

DESIGNER François Gervais
ILLUSTRATOR François Gervais
PAPER Fedrigoni Pergamentata

OFFICE ENVIRONMENTS

Stoltze Design **DESIGN FIRM**
Clifford Stoltze **ART DIRECTOR**
Kyong Choe, Nicole Curran **DESIGNERS**
Fox River Papers Confetti Sable; **PAPER**
Simpson Quest Black

Stoltze Design Office Environments folder This folder, designed for Office Environments of New England, mimics the client's logo. The half-circle die-cut flap refers to the *O* in the logo, and the vertical stripes relate to the three very strong strokes in the *E*. (The striping is also mirrored in the client's stationery.) The repetition in the vertical format makes an architectural reference that is relevant to the business of high-end office furniture. All of the graphics are foil stamped on matte black, flecked stock.

THE CREATIVE PAPERS

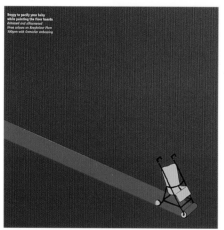

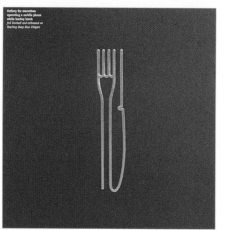

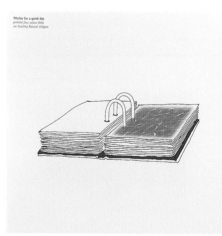

138 PAPER GRAPHICS

DESIGN FIRM Thomas Manss & Company
ART DIRECTOR Thomas Manss
DESIGNERS Thomas Manss, Helen Delany
ILLUSTRATORS Thomas Manss, Helen Delany
PAPER Keaykolour Sandstone 300 gsm;
Yearling Deep Blue 250 gsm;
Keaykolour Plum 300 gsm; Rives
Design Cinder Grey 250 gsm

Thomas Manss Arjo Wiggins promo Arjo Wiggins Fine Paper commissioned this portfolio to promote the company's range of papers. Unlike most paper promos, the papers were not just printed but are an integral part of the design: An umbrella uses the embossing to hint at falling rain, while the flattened (debossed) area under the umbrella indicates a dry patch. A felt-marked paper provides a tablecloth background for foil-stamped cutlery, and a buggy paints the floorboards, created by the texture of the card stock.

DESIGN FIRM Thomass Manss & Company
ART DIRECTOR Thomas Manss
DESIGNER David Law
PAPER Khadi Cotton Rag Paper Sand;
Arjo Wiggins Fine Papers Hi-Speed Opal
Natural 150 gsm; Yearling Mottled White
90 gsm; Arjo Wiggins Countryside
Natural Straw 100 gsm

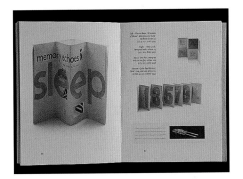

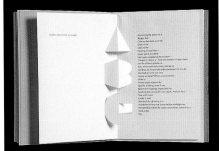

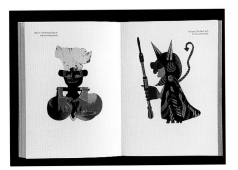

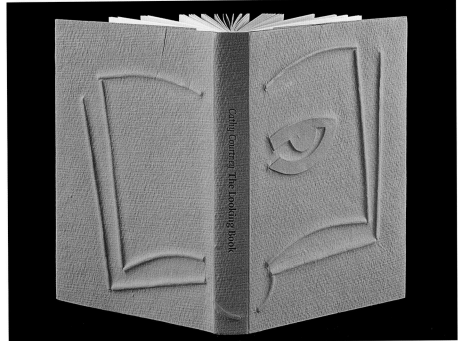

Thomass Manss *The Looking Book* Marking the thirtieth anniversary of Circle Press, a private publisher

producing limited-edition artists' books, *The Looking Book* presents a history of the press. Thomas Manss &

Company's design for the book reflects the belief that the book should not just be a documentation of existing

projects, but also an object with its own personality. Different papers, an embossed jacket and introduction,

and a pop-up section make the book a wonderful and memorable keepsake.

Centradesign Abbondanza/Matos Ribeiro catalog The paper stock specified by Centradesign for the introduction of this Abbondanza/Matos Ribeiro fashion catalog is a Portuguese paper usually used to wrap food items. Because it is a food grade, it is made from virgin eucalyptus and pine pulps without any chemicals, chlorine, or recycled fibers. Its transparent nature and Centradesign's use of gatefolds and posterized, reversed imagery captures attention and engages readers as they turn the pages.

DESIGN FIRM Centradesign
DESIGNER Ricardo Mealha
PAPER Vegetal 70 g Renova

Centradesign Iñes catalog Centradesign takes run-of-the-mill chipboard and makes it extraordinary by blind debossing this fashion-photography catalog's title. The design was Ricardo Mealha's attempt to mirror in the book the pictures and personality of Iñes Gonçalves' photos inside: modern, understated, natural. The red binding tape and red type inside were used to make a strong contrast with the other muted colors, so that the book would not look too soft.

Sense. Design & Innovation Nieuwe Prinsengracht 39 NL 1018 EG Amsterdam
Telefoon +31 (0)20 422 70 18 Telefax +31 (0)20 423 48 80 e-mail sense@euronet.nl
Bank ING 66.76.52.205 B.T.W. nr NL-2026.36.896 Leveringsvoorwaarden gedep. K.v.K. Amsterdam nr 3356

Sense. Design & Innovation Nieuwe Prinsengracht 39
NL 1018 EG Amsterdam e-mail sense@euronet.nl
Telefoon +31 (0)20 422 70 18 Telefax +31 (0)20 423 48 80

Markus Engeli

DESIGN FIRM VeldsVorm Design & Consultancy
DESIGNERS Bart op het Veld, Stephan van de Kimmenade, Marc Koppen
ILLUSTRATOR Walter van der Linde
PAPER Distinction, Alpha paper, Maarssen

VeldsVorm Sense stationery | The corporate identity of Sense Design & Innovation is characterized by a clear and transparent outward appearance, which links perfectly with its name and its less-is-more philosophy. VeldsVorm created a stationery system that matched this image: The company name is printed backward on the back side of the letterhead and memo sheets so that it shows through as a minimal image. The idea of translucency is achieved on the business card not only by printing on both sides, but also by using a high-gloss varnish on the card face.

Vaughn Wedeen Pedal to the Metal book Part of an internal sales-incentive program at US West—a program in which cars were given away for outstanding employee performance—this 4 1/4-inch-square booklet was designed by Vaughn Wedeen Creative to be very different from other, visually noisier program promotions (T-shirts, posters, and the like). Its small size and understated chipboard cover definitely made a statement, as did the tiny sculpted embossed and foil-stamped image at its cover's center. The result is an artifact so precious that many people were loath to throw it away.

DESIGN FIRM Vaughn Wedeen Creative **ART DIRECTOR** Steve Wedeen **DESIGNERS** Steve Wedeen, Pamela Farrington **PAPER** Kraft chipboard (cover); Vintage Velvet Cream Cover (interior)

Pressley Jacobs Platinum Technologies annual report To illustrate the concept of infrastructure in this Platinum Technologies annual report, Pressley Jacobs Design used the veins in a leaf to create a dramatic emboss on the report's cover. (Art director Amy Warner McCarter says that specifying a very soft paper and keeping the emboss away from the edges of the sheet kept the cover from warping.) Inside, vellum pages— die-cut with precisely placed pinholes—alternate with coated pages printed with black-and-white images of many kinds of infrastructure. The pinpoint grid was meant to illustrate the underlying, and often invisible, infrastructure of the systems described by the report.

144 PAPER GRAPHICS

DESIGN FIRM Pressley Jacobs Design
ART DIRECTOR Amy Warner McCarter
DESIGNER Amy Warner McCarter
ILLUSTRATOR Craig Ward
COPYWRITERS Rachel Lang, Linda Thorsen, Paul McComas
PHOTOGRAPHERS Kevin Anderson, Keyvan Beypour, Frans Lanting, Gary Faye, Karen Knauer
PAPER Alpha Cellulose, raw paper pulp (cover); UK Paper Consort Royal Ospery 100 lb. (editorial); French Butcher Off White 60 lb. (financial); CTI Glama (transparent sheets); James River Tuscan Antique 130 lb. (hangtags)

Visual Dialogue **DESIGN FIRM**
Fritz Klaetke **ART DIRECTOR**
Fritz Klaetke, Brenda Schertz (94), **DESIGNERS**
Jason Otero (95), Hana Ruzicka (96),
Sasha Pancholi, Carol Hayes (98)
Alison Seiffer (96), Jeff Brice (98) **ILLUSTRATORS**
Carl Tremblay (95), Kent Dayton **PHOTOGRAPHERS**
Monadnock Revue; Astrolite **PAPER**

Visual Dialogue *Impressions* **magazine** It's every publication designer's dilemma: How do you create a

masthead that functions well with all cover visuals known and unknown? Visual Dialogue neatly solved the

problem for *Impressions*, the alumni magazine for Boston University Goldman School of Graduate Dentistry.

Art director Fritz Klaetke created an embossed masthead that not only allowed almost any cover image to be

used, it also subtly reinforced the title of the publication with its impression on the paper.

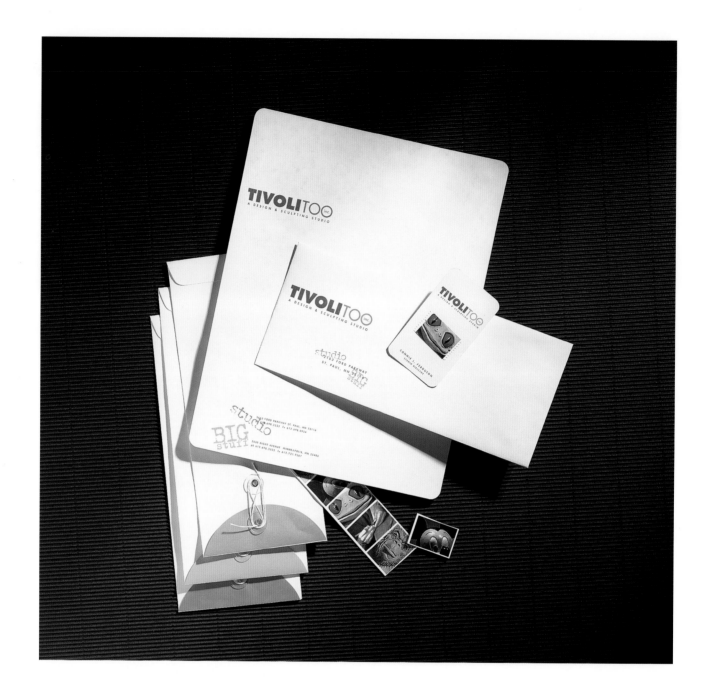

DESIGN FIRM Parachute Design
ART DIRECTOR Cari Johnson
DESIGNER Cari Johnson
PAPER French Durotone Butcher paper

Parachute TrivoliToo stationery | TivoliToo is a studio that provides design, sculpting, and initial molds of collectible and licensed products, as well as design and fabrication of larger objects for signage, retail display, and entertainment venues. Building on TivoliToo's color history of using bright fluorescent shades, Parachute Design updated the scheme with richer, more current colors. Four-color photographic representations of the firm's work are shown on five different stickers, which can be used to add more color to business cards, mailings, and note cards.

Parachute Design **DESIGN FIRM**
Bob Upton **ART DIRECTOR**
Bob Upton **DESIGNER**
Bob Upton **ILLUSTRATOR**
Cougar Opaque Smooth **PAPER**

PRINTED PAPER **147**

Parachute Eat Your Vegetables campaign Eat Your Vegetables was a campaign to introduce a new grocery-store location for an already established chain. A special grand-opening event was tied to a benefit for a non-profit organization that helps families. Parachute Design tied the themes of food and family together with that motherly, "eat your vegetables." All attendees of the event received a sticker-decorated grocery bag full of specialty items from the store and a poster. A bright, white uncoated sheet capable of carrying large areas of flat colors was a must for the project.

DESIGN FIRM Bob's Haus

DESIGNER Bob Dahlquist

PRINTER Full Circle Press (letterpress);
Tom's Printing (lithography)

PAPER Simpson Teton (cards and envelopes);
Neenah UV (overlay)

Bob Dahlquist invitation Designer and letterer Bob Dahlquist's clients wanted to celebrate their wedding anniversary by hosting an elegant evening party for friends in the backyard, but without calling too much attention to their anniversary. So Dahlquist employed elements from the backyard setting—a glimmering pool, hanging wisteria, and moonlight—and he used letterpress on a soft, textured sheet to convey the elegance and romance of the event. A transparent overlay restates the date of the party and adds a shimmering, watery, effect.

Greteman Group Witchita Industries annual report This unusual annual report transcends the usual focus on financials. Instead, it tells what it is like to be blind. The Greteman Group designed the report for Wichita Industries and Services for the Blind with graphics, quotes, die-cuts, and even embossing to dramatically demonstrate the isolation, risk-taking, and reliance on touch that persons with low vision deal with every day. A Braille page speaks to those who are blind, extending the report's communication to the audience serviced by the client.

Greteman Group **DESIGN FIRM**
Sonia Greteman **ART DIRECTOR**
Sonia Greteman, James Strange **DESIGNERS**
Mark Weins **PHOTOGRAPHER**
Allison Sedlacek **COPYWRITER**
Neenah Classic Crest **PAPER**

Emery Vincent Botanical business card Emery Vincent Design created this extremely spare identity for the Botanical Hotel, a restaurant located opposite the beautiful Royal Melbourne Botanic Gardens. The mark is an abstraction of the letter *B* and incorporates segments of botanical drawings of species found within the park. Embossing enhances the visual expression and tactile qualities of the logo while it conveys a sense of the quality and prestige of the hotel. Blind embossing was limited to the business cards.

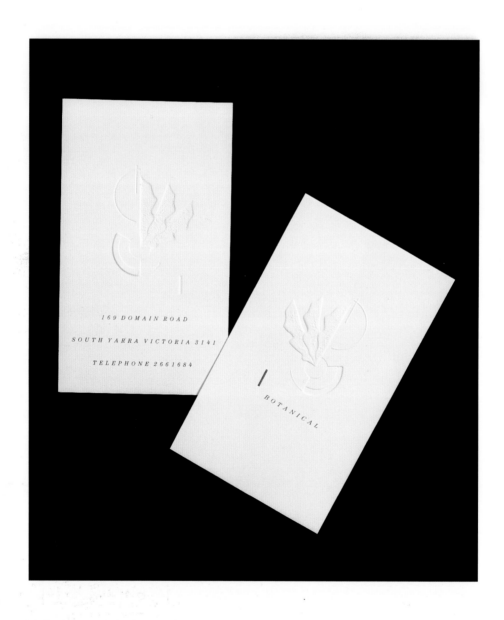

169 DOMAIN ROAD

SOUTH YARRA VICTORIA 3141

TELEPHONE 2661684

BOTANICAL

DESIGN FIRM Emery Vincent Design
DESIGNER Garry Emery
PAPER Saxton Vellum 280 gsm

Richardson or Richardson Communication Design blueprint Communication Design is an interactive-design organization that produces digital video, CDs, private broadcast networks, and many other kinds of digital connectivity projects. Richardson or Richardson chose the form of a blueprint for this promotion to communicate that planning is key to any project. Its unusual poster size, color, and transparent delivery envelope also cut through the clutter of other mailings from the client's competition. Even better, the blueprints were incredibly inexpensive: Printing, trimming, and folding were completed for a few hundred dollars.

Bull Rodger Allan Jones stationery Photographer Allan Jones' stationery is unique not only for its unusual

trim. It is also printed on one of the cheapest papers available: phonebook stock. Principal Paul Rodger mod-

eled the stationery after a page torn from the phone book because all of the photo-type clichés are pretty

much used up by now, and Jones is the commonest name in the phone book. Two inverted letterheads were

placed on one A3 sheet with a crease down the middle. Jones tears them apart as needed, and yes, they go

through a laser printer.

DESIGN FIRM Bull Rodger
DESIGNER Paul Rodger
PAPER Bond paper 90 gsm

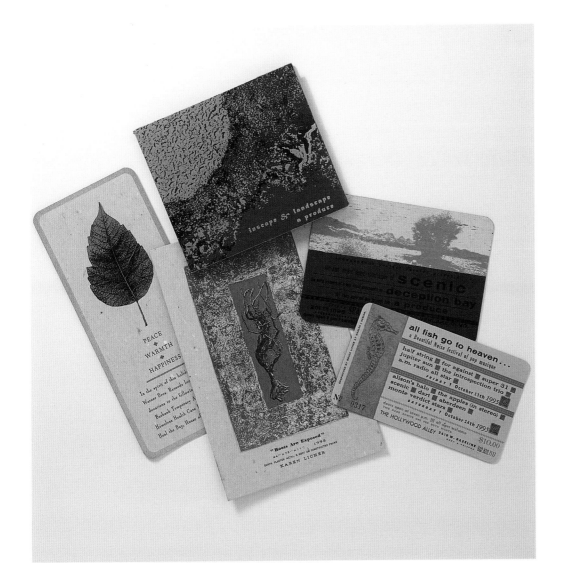

DESIGN FIRM Independent Project Press
DESIGNERS Bruce Licher, Karen Licher
PHOTOGRAPHERS Bruce Licher, Karen Licher
ILLUSTRATORS Bruce Licher, Karen Licher
PAPER Beveridge Ginger Placard; French Durotone Packing Carton; Beveridge Black Railroad Board; Beveridge Buff Railroad Board

Independent Project Press projects Lots of designers are printing on chipboard these days, but Bruce Licher of Independent Project Press could probably be called the crown prince of rough paper. Feeding the most unusual papers he can find into his hand-fed letterpress, Licher produces designs that are beautiful and informative, mysterious, and friendly. For some pieces, he attaches an engraved metal plate to his press, which creates additional debosses and dents. Licher notes that the papers he uses change in color and nature all the time, and sometimes they simply cease to exist: It's something he has become accustomed to, he says. Then Licher simply sets out in search of newer, even more unusual papers.

Peter Felder stationery | The three circles on Peter Felder's stationery visually represent his studio's philosophy: An iridescent, foil-stamped circle represents seeing; a tactile blind-embossed circle represents feeling; and a die-cut circle represents understanding. For Felder, the marks show three different kinds of perception and observation.

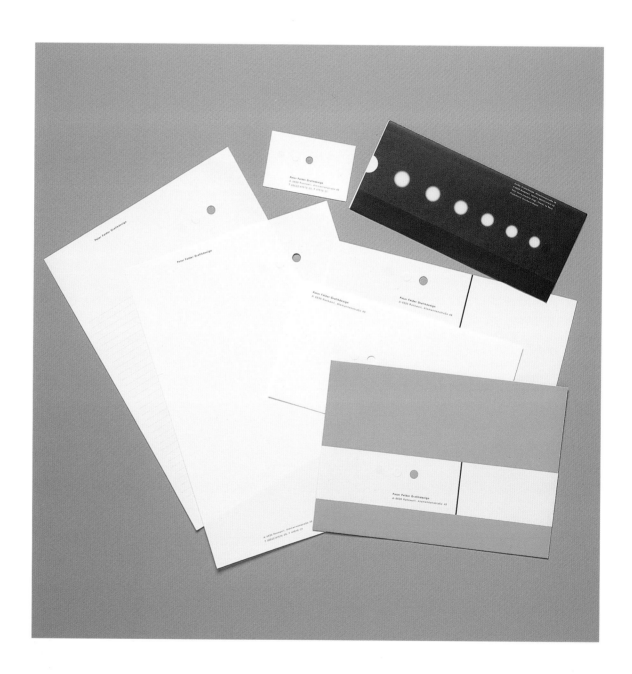

DESIGN FIRM Peter Felder Grafikdesign
DESIGNER Peter Felder
PAPER IT Paper Iskandar

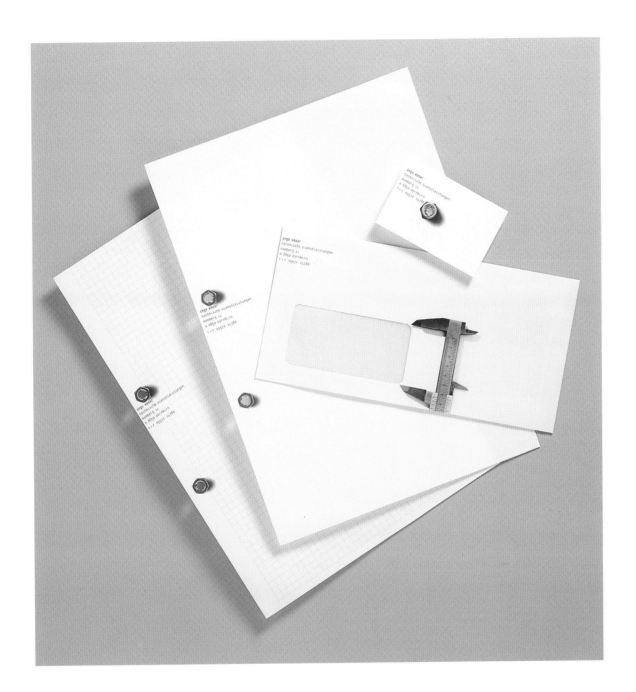

Sigi Ramoser Ingo Maser stationery Ingo Maser is an Austrian master locksmith. To provide him with a stationery system that spoke of his business, designer Sigi Ramoser used photographic images of nuts, bolts, and calipers as images in the design. On the stationery, the centers of the nuts are die-cut, furthering the illusion that they actually sit on the sheet of paper. On the business card, Ramoser connected the nut and bolt by matching their images on either side of the paper, as if a bolt were screwed through and secured there.

MIXED MEDIA

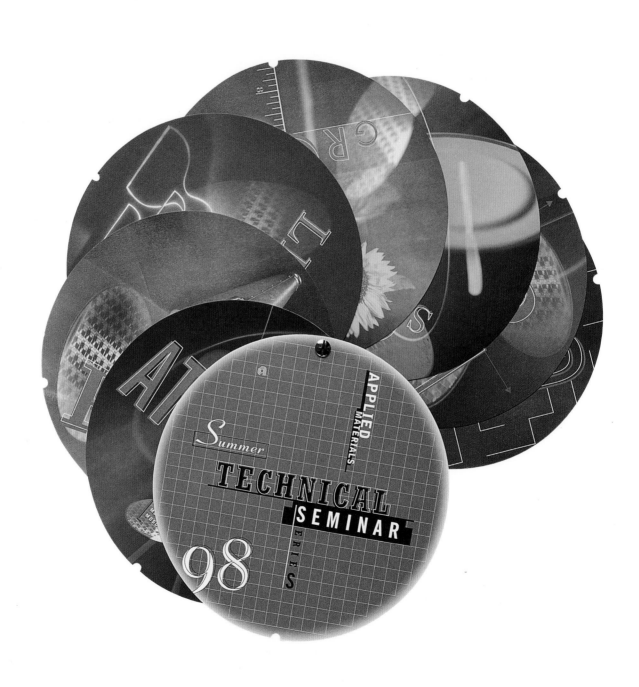

The convention of mixed media is well understood by graphic design-ers. A mixed-media painting contains watercolor, acrylics, oils, and more in any number of permutations. A mixed-media presentation involves sound, visuals, and staging.

But apply the term *mixed media* to paper designs and the definition becomes a little less clear. That's because paper can be combined with literally anything.

Witness this section that contains projects made with paper mixed with velour, boot eyes and hooks, a magnifying glass, red masking film, nuts and bolts, plywood, and more. Much more.

Conceptual acrobatics abound in this area—and why not when paper is flexible enough to mimic other forms, like Cahan & Associates COR annual report, designed to look like a patient's medical chart. Or it is resilient enough to support a liquid-filled pouch, as Peter Felder's Telefonseelsorge brochure does.

The designs in this section were chosen because they remain predominately paper. That's what makes them so charming.

Gee + Chung Design Silicon wafer kit (p. 168)
Paper: Simpson Starwhite Vicksburg Tiara White
Vellum Finish, Cover Plus 110 lb.

DESIGN FIRM Costello Communications
CREATIVE DIRECTOR James Costello
DESIGNER James Costello
PHOTOGRAPHER Kevin Anderson
PAPER Hopper Protera

Costello Communications boot cover | Designer James Costello tied up an intriguing design solution for a LaCrosse Footwear annual report—literally. He hearkened back to the client's main product— heavy-duty footwear—to design a hook-and-eye-latched folder that holds the report, printed with a woolly sock fabric pattern.

Cahan & Associates Cadence 96 annual report In its 1996 annual report, Cadence wanted to show that it not only brought innovative products for electronics designers to market, but also that it helped designers understand and manage the technology. This was a very different paradigm than what was being offered by the competition. In response, Cahan & Associates designed a very different report, covered with a velvety velour stock—a very different design paradigm. Cahan designers and their printer went through a month of trials before they found just the right stock and just the right binding and foil stamping.

FEELS DIFFERENT, DOESN'T IT?

CADENCE 1996 ANNUAL REPORT

Cahan & Associates **DESIGN FIRM**
Bill Cahan **ART DIRECTOR**
Bob Dinetz **DESIGNER**
Royal Blue Velour (cover); Kashmir Text; **PAPER**
100 lb. (interior)

MIXED MEDIA **159**

Cahan & Associates COR Therapeutics 1996 report In an annual report containing case studies that demonstrated the critical relationship between careful diagnosis and optimal treatment for cardiovascular disease, Cahan & Associates adopted the model of a doctor's docket, complete with folder stock cover, metal binding tabs, special reports tucked into card pockets, and even X-ray film. The COR Therapeutics, Inc. report, despite its complexity, was completed in thirty days. This included several all-nighters, during which each of the ten thousand copies was hand assembled.

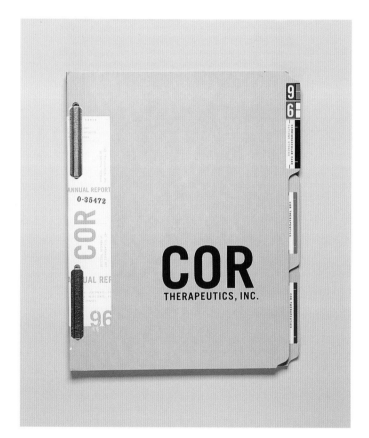

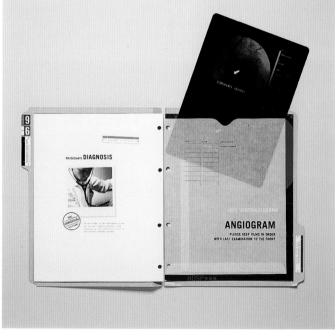

DESIGN FIRM Cahan & Associates
ART DIRECTOR Bill Cahan
DESIGNER Kevin Roberson
ILLUSTRATOR Kevin Roberson
PRINTER Lithographix
PAPER Cougar White Vellum; French Durotone
Gold Primer; Strathmore Elements Grid;
Railroad Board; mylar and manila board

Cahan & Associates Adaptec annual report It is difficult to present through engaging visuals Adaptec's products—chips, circuit boards, and so on. Cahan & Associates felt that emphasizing the net benefit of the products, as well as explaining them in a compelling and accessible manner, was much more important. The friendly form of a children's book seemed a perfect medium. It seduces the reader into learning what might be intimidating information.

Cahan & Associates **DESIGN FIRM**
Bill Cahan **ART DIRECTOR**
Kevin Roberson **DESIGNER**
Richard McGuire **ILLUSTRATOR**
Cougar Vellum (cover) **PAPER**

MIXED MEDIA 161

Cahan & Associates Xilinx annual report Xilinx makes reprogrammable logic devices that, as the technology develops, are capable of holding more and more information in smaller and smaller spaces. Cahan & Associates felt that creating a very small annual report would be an apt physical representation of the client's technology. The finished 6 7/8-by-8 7/8-inch report, wrapped in a financial-page cover, comes complete with a magnifier that coverts the 6-point text into 20-point copy that anyone can read.

DESIGN FIRM Cahan & Associates
ART DIRECTOR Bill Cahan
DESIGNER Kevin Roberson
COPYWRITER Thom Elkjer
PAPER Springhill Incentive Cover 70 lb.
(cover); Mead Richgloss 80 lb. book,
Springhill Incentive 50 lb. (inside)

Dear Fellow Shareholders:
In fiscal 1997, Xilinx recaptured the technological lead and stepped up the pace of innovation in the programmable logic industry. This Annual Report is purposely small. Its reduced size is meant to dramatize how Xilinx uses advanced integrated circuit (IC) technology to increase the density and reduce the size of its devices.

Throughout much of fiscal 1997, a semiconductor-wide inventory correction reduced customer demand. In addition, Xilinx was in the midst of a product transition. Our previously rapid growth slowed. By midyear, we were taking action to get back on track. First, we refocused our R&D resources on our core businesses: SRAM-based field programmable gate arrays (FPGAs) and Flash-based complex programmable logic devices (CPLDs). Second, we dramatically accelerated our adoption of leading-edge semiconductor manufacturing technology in order to increase gate densities, increase device speed, and reduce the cost per device.

These two steps enabled us to sample the industry's first 0.35 micron mixed voltage FPGAs. In addition, we shipped new logic design software and began selling ready-to-use logic cores that reduce time to market for our customers. By our fourth fiscal quarter, revenue growth had returned to historic levels. For the fiscal year as a whole, revenues grew to a record $568 million, up slightly from $561 million in fiscal 1996. Net income was $110 million, or $1.39 per share, up from $102 million, or $1.28 per share, in fiscal 1996.

Accelerating Technology Leadership Programmable logic companies' process technology has traditionally lagged by a generation or more the IC manufacturing technology used by memory companies. This is no longer the case for Xilinx. Based on the technology roadmap we established in fiscal 1997, we are now among the most aggressive adopters of advanced IC technology in the semiconductor industry. We sampled our first products using 0.35 micron IC process technology in fiscal 1997, and we plan to introduce 0.25 micron in fiscal 1998.*

It took us ten years to increase FPGA density from 1,000 gates to 25,000 gates. Following our current technology roadmap, we believe we will make another exponential leap, from just over 25,000 to 200,000 gates, in about two years, or a quarter of the time required for the last leap.* At the same time, we are leveraging advanced IC process technology to slash product prices. For example, a 10,000-gate Xilinx FPGA that sold for more than $100 in 1994 sells for approximately $10 today.

When transistors on semiconductor devices shrink below 0.5 micron in size, the devices themselves require power supplies lower than the current standard of 5 volts. In fact, each new generation of transistor size will require a correspondingly lower voltage. Xilinx is now the only programmable logic supplier with pin compatibility between devices of different voltages. That means only Xilinx customers can replace a 0.5 micron FPGA with a higher-performance 0.35 micron FPGA without having to redesign the circuit board. Thus Xilinx FPGAs form a bridge between the technological past and future. Our customers can evolve their product designs in stages, selecting the Xilinx FPGAs that give them the best combination of density, speed, power and price.

Delivering Complete Solutions When Xilinx pioneered FPGAs, we changed the way our customers designed and developed their products. Now we're changing the way logic itself is designed. Looking forward, customers will no longer design large-density FPGAs one gate at a time. They will integrate complex logic designs into their products at the system-level. Xilinx has a superior understanding of the system-level challenges of programmable logic. We offer complete solutions based on that understanding and partner with our customers to guide them through the complexities of submicron IC technology. In addition, as customers design products using FPGAs of 100,000 gates or more, they need more sophisticated design software. They also need pre-implemented cores of logic that help reduce time to market. Xilinx provides both types of software as part of an integrated solution. In such a challenging technological domain, field support becomes critical to assure customers that their logic devices, design software, and logic cores work together flawlessly. Xilinx provides that level of support, around the clock and around the world. The end result is that Xilinx is becoming a strategic, system-level solutions provider for many companies.

At the heart of the Xilinx solutions strategy is our XC4000X family: the highest-density, fastest-speed, and lowest-power FPGAs on the market today. We are also pushing strongly into the market for CPLDs by delivering innovative architectural features at the industry's lowest prices. During product (SEE BACK COVER)

XILINX
1997 ANNUAL REPORT

Founded in 1984, Xilinx is the world's largest supplier of programmable logic solutions providing electronic equipment manufacturers worldwide with faster time to market and increased flexibility. The reduced size and densely packed cover of this annual report symbolizes a Xilinx semiconductor chip, physically demonstrating our focus on increasing density while reducing the size of programmable logic devices. The attached magnifier will help you read about Xilinx leadership in silicon, software, and support. Inside, the report shows how Xilinx has established a new competitive roadmap through the programmable logic landscape.

IC TECHNOLOGY ROADMAP
High Density – High Performance

AS XILINX AGGRESSIVELY ADOPTS MORE ADVANCED PROCESS TECHNOLOGIES, THE BENEFITS TO OUR CUSTOMERS ARE TWOFOLD: NOT ONLY CAN WE BE FIRST TO MARKET WITH THE DENSEST, FASTEST AND LOWEST POWER DEVICES, BUT WE CAN MIGRATE OUR EXISTING PRODUCTS TO SMALLER GEOMETRIES, THEREBY DRAMATICALLY REDUCING THE PRICE PER DEVICE.

IC PRODUCT STRATEGY

Pressley Jacobs Design **DESIGN FIRM**
Amy Warner McCarter **ART DIRECTOR**
Amy Warner McCarter **DESIGNER**
Wendy Pressley-Jacobs **CREATIVE DIRECTOR**
Susan Bukacek, Beth Savage, **COPYWRITERS**
Laurie Velicer, Dave Bucanan,
Hammermill newsprint **PAPER**

MIXED MEDIA **163**

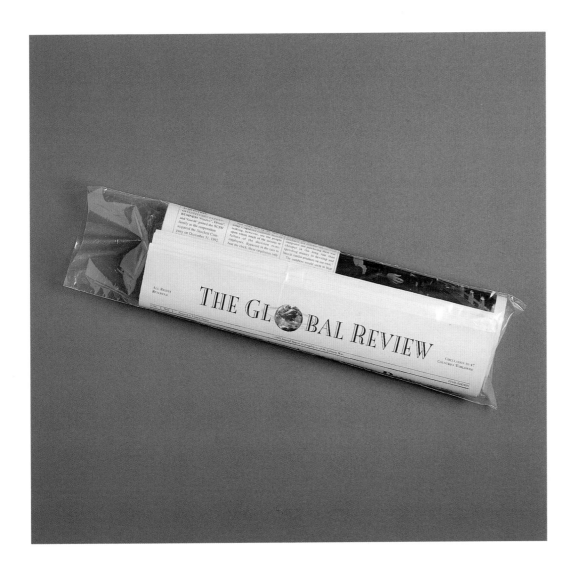

Pressley Jacobs' SC Johnson Wax annual report | When asked by client SC Johnson Wax to create an

employee annual report that was more economical, more user-friendly, and more readable than traditional

annual reports, designers at Pressley Jacobs took cues from the newspaper. The broadsheet design was folded,

rolled, and delivered to employees' desks in a plastic sleeve, completing the newspaper allusion.

DESIGN FIRM Sterling Design
DESIGNER Jennifer Sterling
PHOTOGRAPHERS John Casado, Dave Magnusson, Tony Stromberg, Marko Lavrisha
PAPER Gilclear Cream; Zellerbach Vellum

Sterling Design portfolio | Sterling Design's objective for this unusual portfolio was to create a collection that reflected five different areas of work and design sensibilities. Vellum and opaque sheets are bound to a brushed-metal back with a single screw, which allows the brochure to be updated frequently and easily. Metal tabs demarcate sections, and the entire package slips into a metal mesh case. Most of the images look good in any overlaid position: There is something appealing about seeing through to the next two or three layers at the same time.

Sterling Design bHoss promo bHoss was a new band with limited resources. But it did have an abundance of wonderful work to draw from conceptually. So Jennifer Sterling of Sterling Design turned all of the group's lyrics into illustrations and letterpress printed them on CD shapes. On one side of a coaster is the song title; on the opposite side are the words. The disks are die-cut at center and held together with a single bolt.

Sterling Design **DESIGN FIRM**
Jennifer Sterling **ART DIRECTOR**
Jennifer Sterling **DESIGNER**
Rohner Letterpress **PRINTER**
Coaster.stock **PAPER**

DESIGN FIRM Greteman Group

ART DIRECTORS Sonia Greteman, James Strange

DESIGNERS Sonia Greteman, James Strange

COPYWRITERS Sonia Greteman, James Strange, Bart Wilcox

PAPER Carnival Groove; acetate

Greteman Group Duffens Optical book | Duffens Optical's no-line bifocals were the focus of this combination marketing brochure and direct-mail piece, sent to optometrists. The Greteman Group took a literal approach in its design solution. Lined stock, cut into lens shapes, reinforces the subject, as do the clear acetate pages used throughout the promo. When the pages are turned, once-visible imagery—lines printed on the acetate—disappear. Humor reinforces the line theme through representations of long lines at a bank, tired lines spoken in a bar, and interference lines on a television.

DESIGN FIRM blackcoffee design

DESIGNERS Laura Savard, Mark Gallagher

PAPER Colored acetates; Beckett Ridge Dijon 80 lb. Cover; Beckett Paradox Smokey Smooth 70 lb. Text

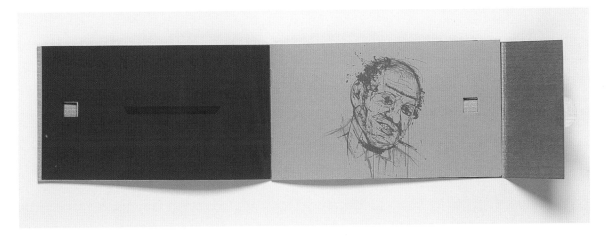

blackcoffee design Halloween party invitation blackcoffee design chose a Dr. Jekyll and Mr. Hyde theme for its 1997 Halloween party; the firm's designers wanted to create a design that graphically represented the monster's transformation. Soon they realized that transparent red films would achieve the effect they wanted: Laid atop printed pages, the red plastic sheets hid and subsequently revealed nasty scenes on several spreads of the five hundred-piece run. The most difficult aspect of the design, reports designer Laura Savard, was figuring out the ink colors that worked perfectly with the acetates.

Gee + Chung Design Silicon wafer kit Gee + Chung Design client Applied Materials has a new copper

fabrication process that allows it to etch more silicon chips on thinner layers of the wafer, creating a higher

yield of information per wafer. So when the client asked for an invitation for a series of seminars about the

technology, Earl Gee's designers created a wafer-shaped mailer packaged in a metalicized mailer. The unusual

screw-bound mailer, Gee reports, more than doubled seminar attendance compared with the previous year.

DESIGN FIRM Gee + Chung Design
ART DIRECTOR Earl Gee
DESIGNERS Earl Gee, Fani Chung
PHOTOGRAPHER Keven Irby
PRINTER Forman Lithograph
PAPER Simpson Starwhite Vicksburg,
Tiara White Vellum Finish, Cover Plus
110 lb. (disks); Static-control recloseable
shielding bag

Jeanette Hodge Design Slow Club menu placards Designer Jeanette Hodge says that the idea behind her

Slow Club menu placards comes from the simple directness of the restaurant's food offerings. Stained deep

red on one side and screen printed with graphics on the other, the plywood menu holder is durable, Hodge

says. Its combination of lightness and hardness offers a surprising, even jarring tactile dimension—especially

at night, when the restaurant is very dimly lighted.

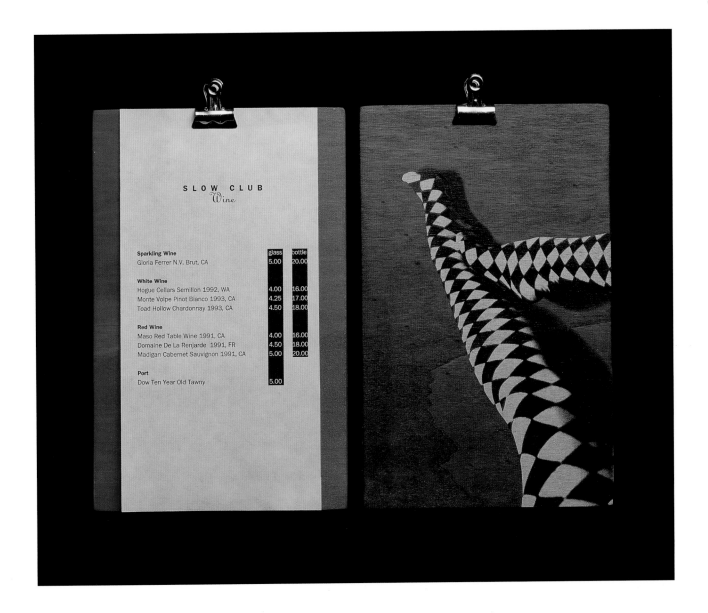

DESIGN FIRM Peter Felder Grafikdesign
ART DIRECTOR Peter Felder
DESIGNERS Peter Felder, René Dalpra
COPYWRITERS Barbara Bohle, Philipp Bohle and others
PAPER Offset White 190 gsm

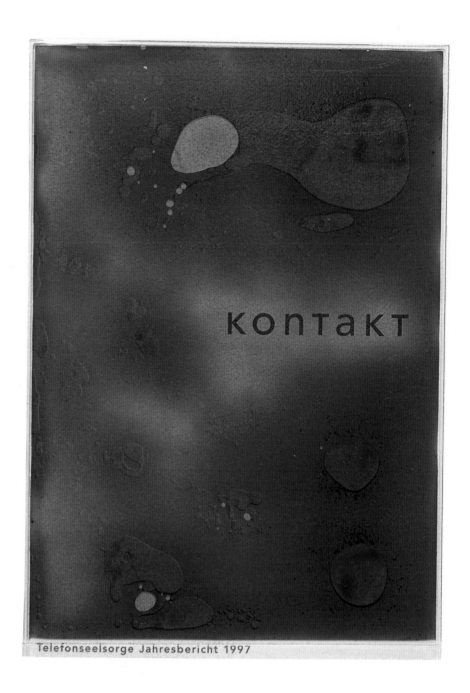

Peter Felder Telefonseelsorge Jahresbericht booklet The cover of this annual report, designed by Peter Felder Grafikdesign for a social institution whose volunteers use the phone to do their good works, is truly an interactive experience. A special plasticard is filled with different colors of nonmixable liquids. When the reader gets in touch with the cover, moving his or her finger across the plasticard, the transparent fluids move, which creates a design that changes with each reading.

blackcoffee design Powerhouse Interactive Awards announcement blackcoffee design got the call for this assignment, an invitation to an awards/trade show, late on a Friday. The video company client needed the finished piece the following Friday. Wanting to create a brochure with high impact and fast turnaround, the studio's designers devised an irregular fold that compacted a 7-by-11-inch sheet into a shape that was impossible to ignore. The finishing touch: The piece is held shut with a bellyband made from videotape.

blackcoffee design **DESIGN FIRM**
Mark Gallagher, Laura Savard **DESIGNERS**
Fox River Confetti Blue 80 lb. Cover **PAPER**

MIXED MEDIA 171

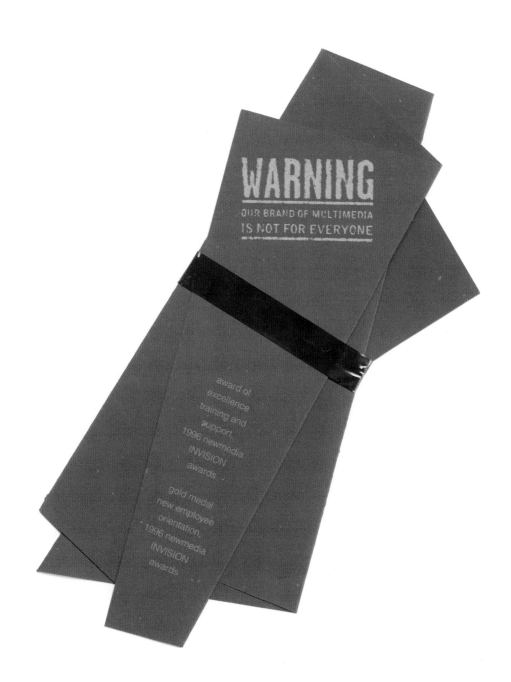

PAPER COLOR

Ich werde vierzig und das möchte ich mit euch feiern.

Samstag, 25. Jänner 1997 20 Uhr Pfarrsaal Hatlerdorf

Bitte um Antwort bis 15. Jänner 1997

When we're handed that very first piece of thick, bright, chunky construction paper in grade school, the fascination begins: The visceral impact of the paper color makes an immediate and lasting impression.

But as we grow older, more and more white paper is injected into our lives—newspapers, bills, memos, faxes, reports, and more. We are adrift in a blizzard of white, and the storm shows no sign of abating.

Colored paper cuts through the clutter. It hearkens back to a day when paper was associated with fun, not just more and more work.

No one can deny the sense of energy conveyed by Cross Colours' stationery system, shown later in this section. Even rawer is the colored paper pulp that Thomas Manss selected for the cover of his Hotel Arts Barcelona menu.

Specifying white or beige paper certainly is not a design cop-out: Only certain projects have a window that is open to using colored paper. But when conceptually and physically appropriate, colored stock adds a special flavor, one simply unavailable from plain old vanilla paper.

Sigi Ramoser Ich werde slip sheet card (p. 184)
Paper: Anders Reflex Hochtransparent 110 g

DESIGN FIRM Wages Design
DESIGNER Ted Fabella
ILLUSTRATOR Ted Fabella
PAPER Champion Benefit 80 lb. cover in Ochre, Natural Kraft, Celery, Bluebird Waylaid

Wages Design Ted Fabella postcards For a postcard announcing an AIGA talk on The Color of Design, designer Ted Fabella had to work with donated paper and printing. But rather than working with just one color of the donated paper, he selected four shades, which pleased the paper manufacturer and created a more interesting suite of cards. Each recipient received one of the four color combinations. Fabella felt that this was a nice touch of variation, especially in studios with multiple recipients.

Mires Design California in 3-D catalog For a catalog for an exhibition of big, bright, contemporary California sculpture, Mires Design specified paper that reflected the art as well as California's warmth and vibrancy. Then the firm ordered a multilevel blind emboss for the catalog cover; there is no printing. The invitation to the exhibition opening was printed in one color, also with a multilevel emboss. The red stock symbolized the primary nature of the art, and the green stock represented an installation of landscape architecture.

Mires Design **DESIGN FIRM**
John Ball **ART DIRECTOR**
Deborah Horn **DESIGNER**
Champion Carnival **PAPER**

PAPER COLOR 175

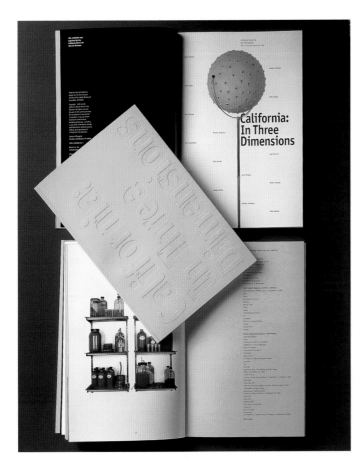

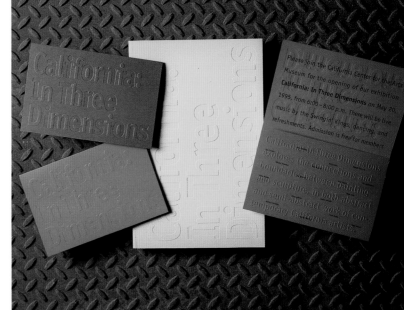

Amanda Bedard business cards | Letterpress printing allowed designer Amanda Bedard to use a variety of stocks for her singular business cards. The hand-tied ribbon—laced through a slit cut by the printer—links the designs no matter what color is used. Spielman says the assembled nature of the cards reflects the nature of her business.

DESIGN FIRM Spielman Design
DESIGNER Amanda Bedard
PAPER Fox River Confetti in Yellow, Rust, Red; Frida Flack (card with no ribbon)

Amanda Bedard duplex card | This card, designed for an interior designer by Amanda Bedard, folds over, but not just to make it appear special. The card also functions as a fabric swatch holder. Specifying a duplex stock adds a second paper color at no cost. Spielman says that the card reflects the interior designer's work—clean and visually elegant.

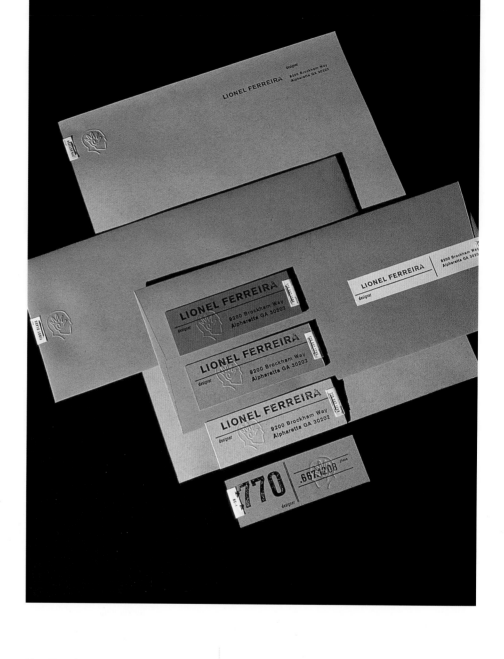

DESIGNER Lionel Ferreira
ILLUSTRATOR Lionel Ferreira
PAPER French Construction in Whitewash, Brick Red, Steel Blue; French Durotone Packing Gray Liner, Packing Brown Wrap

Lionel Ferreira business cards and stationery | Lionel Ferreira wanted a stationery system that was tactile, colorful, and very personal, as well as a design that counteracted in a meaningful way what he terms "the computer craze." His answer was a completely handmade letterhead, envelope, and business card. For his cards, cover-weight paper is doubled over and a laser-printed, hand-embossed text-weight paper is adhered to it. Then the phone number tab is stapled onto the end. The envelopes and letterhead are also hand embossed and stapled with tabs.

Thomas Manss Hotel Arts Cafe Veranda menu Unlike the British, Spanish locals rarely eat in hotel restaurants. To attract such a reluctant clientele, Hotel Arts Barcelona has given each of its bars and restaurants an independent look. The menus are designed to emphasize this individuality, using the arts to retain a thematic tie with the hotel identity. Thomas Manss & Company created this beautiful illustration on the Cafe Veranda menu using colored paper pulp to create a relief of a beach scene.

Thomas Manss & Company **DESIGN FIRM**
Thomas Manss **ART DIRECTOR**
Thomas Manss **DESIGNER**
Ingrid Darrakott **ILLUSTRATOR**
Handmade paper and colored paper pulp **PAPER**
(illustration); Parilux matte cream
300 gsm (cover)

PAPER COLOR 179

Café Veranda

ART DIRECTOR George Tscherny

DESIGNER George Tscherny

ASSISTANT DESIGNER Mathew Cocco

PAPER Starwhite Vicksburg Tiara 80 lb. cover

George Tscherny Putnam Lovell and Thornton pieces "Generally," says legendary designer George

Tscherny, "color selection is determined by judging its appropriateness to the subject." In this project, for an

annual symposium, very distinct colors were used for another purpose as well: To provide a quick visual dis-

tinction between handouts. The simple palette, printed to bleed on the three main pieces, plays sharply off the

matte white of the paper.

Bull Rodger masseuse stationery | Bull Rodger's design for masseuse Nina Triggs' stationery came from try-

ing to find a really simple, inexpensive way of illustrating what a masseuse actually does. The idea of having

the business owner scrunch up the top right-hand corner of the (Caucasian) flesh-colored stock before sending

out the stationery caused a lot of uproar, even from Britain's Design and Art Director's Association: When Bull

Rodger submitted it to a D & AD competition, the selection committee called to ask for more samples, believ-

ing that the original submissions had gotten "screwed up in the post."

DESIGN FIRM Bull Rodger
DESIGNER Steve Lloyd
PAPER Classic Wove Ultra White 250 gsm

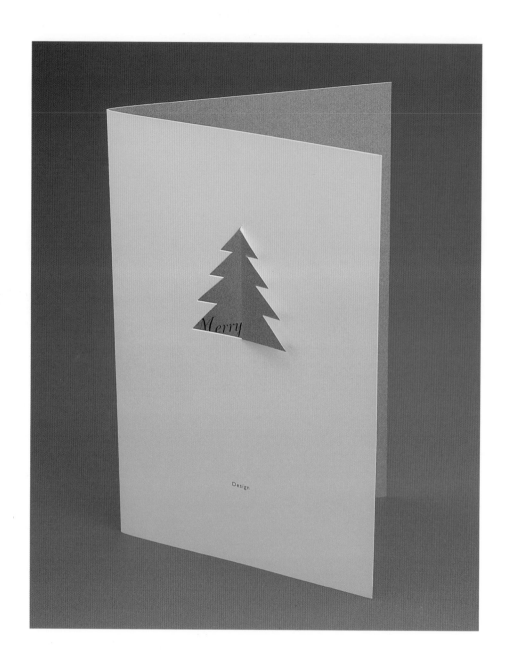

Bull Rodger Christmas card A duplex stock (created by bleed printing one side of a white stock) and a simple die-cut and fold create a very simple, very clever, very elegant holiday card for Bull Rodger. The design also allowed each of the partners—one a designer and one a copywriter—to have a panel to promote their wares.

Visual Asylum Jonathan Woodward stationery Whenever callers phone photographer Jonathan

Woodward's studio, they hear his pet bird Charlie yelling in the background. Visual Asylum knew that Charlie

had to be part of Woodward's identity system. A rich palette of down-to-earth paper colors reflected the pho-

tographer's personal style.

DESIGN FIRM Visual Asylum

CONCEPT Joel Sotelo, Mae Lin Levine

DESIGNER Joel Sotelo

PAPER French Paper Durotone in Packing Brown, Primer Gold, Primer Green

Sigi Ramoser Ich werde slip sheet card Both images on this birthday card are photos of a friend and printing collaborator of designer Sigi Ramoser. On the occasion of his friend's fortieth birthday, Ramoser created a card that showed the birthday boy at his current age and at age three. Overprinting the images in fresh, happy colors on transparent stock removed the "dated-ness" of the old photo and brought both photos into a simultaneous universe where both versions of the same person can exist.

DESIGNER Sigi Ramoser
PAPER Anders Reflex Hochtransparent 110 g

DESIGN FIRM Kym Abrams Design
ART DIRECTOR Kym Abrams
DESIGNERS, ILLUSTRATORS Amy Nathan (stationery, 1996 Christmas card); Kerry Lacoste (1997 Christmas card); Holly Puff (spring promotion)
PAPER Crane's Crest Fluorescent White, Wove Finish (stationery); Mohawk Superfine, Eggshell Finish 80 lb. (1996 and 1997 cards, spring promo)

Kym Abrams Design Lovell & White stationery Lovell & Whyte, a shop that offers decorative items for the home and garden, needed a simple but elegant design to convey the nature of its goods. Kym Abrams Design devised a cut-paper-style illustration for the store's logo, then printed it in a sophisticated gray, white, and black scheme. The interplay between the paper colors and the expandable logo art creates an almost never-ending line of design and copy possibilities.

DESIGN FIRM Deborah Schneider Design, Inc.
PAPER Mohawk Superfine Cover 100 lb.

Deborah Schneider Design Invitation | This bar mitzvah invitation, designed by Deborah Schneider Design, references a tallis, a traditional woven prayer shawl. A textured, cloth-like sheet, letterpress printing, and inter-woven shades of blue reinforced the shawl concept. The stripes of what looks like stitching at the ends of the very horizontal piece actually are the first and last names of the bar mitzvah celebrant, pushed into textured bars.

Lippa Pierce D & AD booklet D & AD, a British design organization, needed a recruitment leaflet that would make people feel that having work accepted into a D & AD Annual signified that their thinking was original and different. Lippa Pierce Design centered on a solution of placing the word *back* on the front of the brochure and vice versa. The two ingredients of the design, a paper that looked handmade and deeply embossed words, emphasized the notion of individual craft. The textured cover contrasts with the coated pages inside, resulting in a publication very different from a standard glossy brochure.

DESIGN FIRM Lippa Pierce Design, Ltd.
DESIGNER Domenic Lippa
PAPER Not available

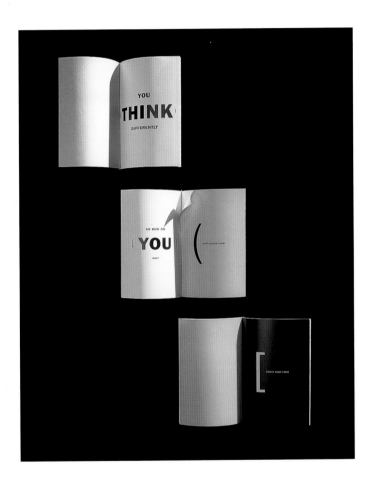

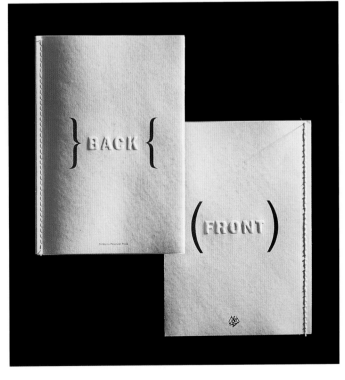

A Hill Design Form + Function stationery | Form + Function is a high-design lighting store. Because the type of business is not mentioned in the name, A Hill Design wanted to convey lighting in its design for the store's identity without restricting the image to that concept because the client also sells other household items. The firm's solution was a loosely drawn, colorful light bulb—emblematic of lighting as well as of great ideas in general—printed in five colors on adhesive stock and adhered to a rich, mustard-colored stock.

DESIGN FIRM A Hill Design
DESIGNERS Sandy Hill, Emma Roberts
PAPER Confetti, Yellow Text 80 lb.

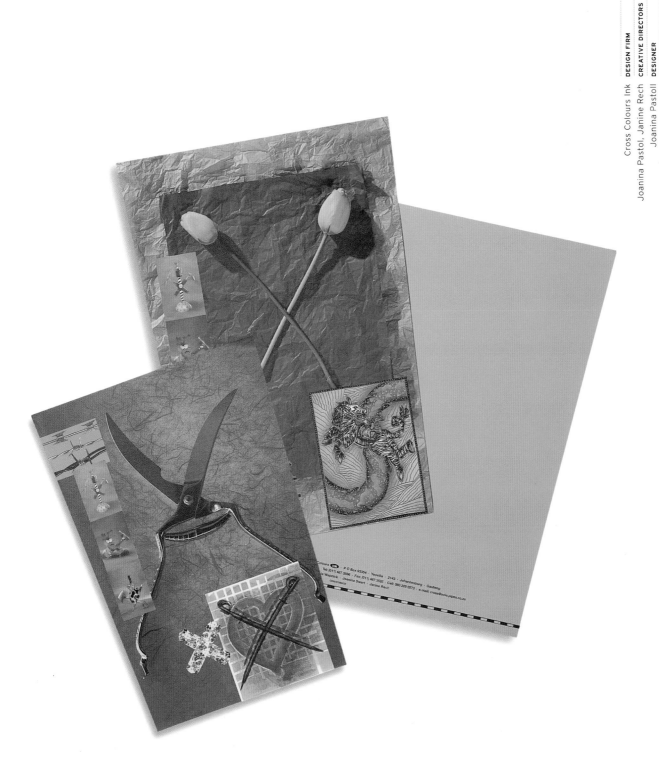

DESIGN FIRM Cross Colours Ink
CREATIVE DIRECTORS Joanina Pastol, Janine Rech
DESIGNER Joanina Pastoll
PHOTOGRAPHER David Pastoll
ILLUSTRATORS Peter Simpson, Robbie Owens, Janine Rech
PRINTER Print Dynamix
PAPER Not available

Cross Colours stationery Based on the premise that an identity need not have a uniform brand presence,

Cross Colours' stationery offers different experiences to recipients. Five-color bleed printing in a range of col-

ors on both sides of the stationery and angled trims makes the stationery and business cards as unconventional

as they are eye-catching. Four-color art is printed on the backs of all the pieces to create even more interest.

DIRECTORY

@KA 26, 27, 51, 89, 90, 91
42 Leamington Road Villas
London, England W11 1HT
011 44 171 727 4491 t+f

A Hill Design 188
121 Tijeras NE
Albuquerque, NM 87102
505-242-8300 t
505-242-2585 f

Agnew & Corrigan Advertising 10
226 N. Arch St.
Lancaster, PA 17603
717-299-1059 t
717-299-1622 f

Anna Wolf 58
2214 Los Angeles Ave.
Berkeley, CA 94707
510-525-7900 t+f

Arts & Letters 95
3214 Hewitt St.
Falls Church, VA 22042-2508
703-560-1717 t
703-560-8430 f

Ashley Booth Design 47, 53
Sagveien 23C 11
Oslo, Norway
0458
011-47-22-80-69-80 t
011-47-22-38-69-08 f

Babsi Daum 102, 108
Andreasgasse 9/3
A-1070 Vienna, Austria
011-43-1-5244904 t
011-43-1-5235905 f

Bailey Lauerman 66, 103, 104
& Associates
900 NBC Center
Lincoln, NB 68508
402-475-2800 t
402-475-5115 f

blackcoffee design 24, 50, 86, 87, 132,
249 A St., Studio 15, 167, 171
Boston, MA 02210
617-292-0544 t
617-292-4732 f

Bob's Haus 78, 148
3728 McKinley Blvd.
Sacramento, CA 95816-3418
916-736-9550 t+f

Bohatsch Graphic Design GmbH 48
Mariahilfer Strasse 57-59/8C
A-1060 Vienna, Austria
011-43-1-581-69-30 t
011-43-1-581-77-38 f

Bull Rodger 17, 127, 152, 181, 182
35 Heddon St.
London, England W1R 7LL
011-44-171-734-9595 t
011-44-171-734-9955 f

Cahan & Associates 45, 72, 73, 105,
818 Brannan St. 135, 159-162
San Francisco, CA 94103
415-621-0915 t
415-621-7542 f

Centradesign 140, 141
Av. Eng. Duarte Pacheco
Torre 2, Pisa 2, No. 10
1070 Lisboa, Portugal
011-351-382-53-40 t
011-351-365-62-74 f

Chermayeff & Geismar, Inc. 59
15 East 26th St.
New York, NY 10010
212-532-4499 t
212-889-6515 f

Costello Communications 158
1415 N. Dayton, Suite 301
Chicago, IL 60622
312-255-9825 t
312-255-0950 f

Cross Colours Ink 18, 49, 109, 189
P.O. Box 47098
Parklands 2121
South Africa
011-27-11-442-2080 t
011-27-11-442-2086 f

Deborah Schneider 76, 186
Design, Inc.
900 N. Franklin, No. 708
Chicago, IL 60610
312-642-3756 t
312-642-9117 f

Design: M / W 69
149 Wooster Street, 4th floor
New York, New York 10012
212-982-7621

Emery Vincent Design 62, 63, 150
80 Market St.
Southbank, Victoria 3006
Australia
011-61-3-9699-3822 t
011-61-3-9690-7371 f

Enormous Egg Designs 110, 114
1411 Skylark Dr.
Boise, ID 83702
208-343-9917 t

François Gervais 136
Y-tech Building
Van Diemenstraat 48
1013 NH Amsterdam
The Netherlands
011-31-20-6-23-71-14 t
022-31-20-6-38-88-92 f

Gee + Chung Design 156, 168
38 Bryant St., Suite 100
San Francisco, CA 94105
415-543-1192 t
415-543-6088 f

George Tscherny, Inc. 21, 180
238 E. 72nd St.
New York, NY 10021
212-734-3277 t
212-734-3278 f

Greteman Group 149, 166
142 N. Mosley
Wichita, KS 67202
316-263-1004 t
316-263-1060 f

Henderson Tyner Art Co. 11, 71
315 B. Spruce St., Suite 299
Winston Salem, NC 27101
336-748-1364 t
336-748-1268 f

Hornall Anderson 98, 120
Design Works
1008 Western Ave., Suite 600
Seattle, WA 98104
206-467-5800 t
206-467-6411 f

Independent Project Press 153
40 Finley Dr.
Sedona, AZ 86336
520-204-1332 t+f

Jeanette Hodge Design 122, 123, 169
471 Linden St.
San Francisco, CA 94102
415-626-8050 t
415-431-2636 f

Karin Beck, 42, 107, 130, 131
Grafische Gestaltung
Messinastrasse 13
FL-9495 Triesen, Liechtenstein
011-41-75-390-09-30 t
011-41-75-390-09-31 f

Kym Abrams Design Inc. 185
213 West Institute Place
Suite 608
Chicago, IL 60610
312-654-1005 t
312-654-0665 f

Lionel Ferreira 178
9200 Brockham Way
Alpharetta, GA 30022
770-667-1208 t

Lippa Pearce Design Ltd. 19, 187
358a Richmond Road
Twickenham TW1 2DN
England
011-44-181-744-2100 t
011-44-181-744-2770 f

Louey/Rubino Design Group 15, 116, 134
2525 Main St., Suite 204
Santa Monica, CA 90405
310-396-7724 t
310-396-1686 f

Love Packaging Group 40
410 E. 37th St. N.
Wichita, KS 67219
316-832-3203 t
316-832-3293 f

Mark Russell Associates 93
Marine Midland Tower
360 S. Warren St.
Syracruse, NY 13202
315-233-3000 t
315-233-4000 f

Matsumoto, Inc. 43, 44, 112
220 W. 19th St.
New York, NY 10011
212-807-0248 t
212-807-1527 f

Michael Bartalos 79, 88
30 Ramona Ave., No. 2
San Francisco, CA 94103
415-863-4569 t
415-252-7252 f

Mires Design 94, 119, 175
2345 Kettner Blvd.
San Diego, CA 92101
619-234-6631 t
619-234-1807 f

Miriello Grafico 37, 80, 81, 97
419 West G St.
San Diego, CA 92101
619-234-1124 t
619-234-1960 f

The Office of Ted Fabella 174
1271 Moores Mill Road
Atlanta, GA 30327
404-351-6692 t
404-351-3136 f

Pangborn Design, Ltd. 25, 38, 55, 56
275 Iron St.
Detroit, MI 48207
313-259-3400 t
313-259-5690 f

Parachute Design 35, 61, 146, 147
120 S. 6th St., No. 1475
Minneapolis, MN 55402
612-359-4387 t
612-359-4390 f

Peter Felder Grafikdesign 16, 83, 154, 170
Alemannenstrasse 49
A-6830 Ranweil
Austria
011-43-0-5522-41510-20 t
011-43-0-5522/41510-21 f

Peter Vogt and Neudel 41
Verpackungen GmbH
c/o Lamy
Grenzhöfer Weg 32
D-69111 Heidelberg, Germany
06221-843-224 t
06221-843-132 f

Peterson & Company 77
220 N. Lamar, Suite 310
Dallas, TX 75202
214-954-0522 t
214-954-1161 f

Pressley Jacobs Design 32, 144, 163
101 N. Wacker Dr.
Chicago, IL 60606
312-263-7485 t
312-263-5410 f

Richardson or Richardson 117, 151
1301 E. Bethany
Phoenix, AZ 85014
602-266-1301 t
602-266-0908 f

Sagmeister Inc. 8, 12, 13, 57,
222 W. 14th St. 67, 68, 85, 92
New York, NY 10011
212-647-1789 t
212-647-1788 f

Sayles Graphic Design 64, 70
308 Eighth St.
Des Moines, IA 50309
515-243-2922 t
515-243-0212 f

Selbert Perkins Design 22
2067 Massachusetts Ave.
Cambridge, MA 02140
617-497-6605 t
617-661-5772 f

Sigi Ramoser Graphik Design 124, 125,
Sägerstrasse 4 155, 172, 184
A-6850 Dornburn
Austria
011-43-5572-27481 t
011-43-5572-27484 f

Sixth Street Press 121
3943 N. Sixth St.
Fresno, CA 93726
209-222-9278 t
209-229-4282 f

Susan Skarsgard 20, 74, 75
807 Hutchins Ave.
Ann Arbor, MI 48103
810-986-4104 t

Spielman Design 118, 176, 177
10 Deer Run Road
Collinsville, CT 06022
860-693-2261 t
860-693-3826 f

Sterling Design 54, 82, 164, 165
5 Lucerne, Suite 4
San Francisco, CA 94103
415-621-3481 t
415-621-3483 f

Stoltze Design 137
49 Melcher St, 4th Floor
Boston, MA 02215
617-350-7109 t
617-482-1171 f

Thomas Manss & Company 29, 60,
116 Regents Park Road 138, 139, 179
London NW1 8UG
011-44-171-722-3186 t
011-44-171-722-5273 f

Troller Associates Graphic Design 133
12 Harbor Lane
Rye, NY 10580
914-698-1405 t
914-698-2316 f

Vaughn Wedeen Creative Inc. 30, 31,
407 Rio Grande NW 113, 128, 143
Albuquerque, NM 87104
505-243-4000 t
505-247-9856 f

VeldsVorn 99-101, 142
Nieuwe Prinjengracht 39
1018 EG Amsterdam
The Netherlands
011-31-20-626-6041 t
011-31-20-620-9109 f

Visual Asylum 46, 183
343 4th Ave., No. 201
San Diego, CA 92101
619-233-9633 t
619-233-9637 f

Visual Dialogue 33, 34, 36, 106, 145
429 Columbus Ave., No. 1
Boston, MA 02116
617-247-3658 t+f

Vrontikis Design Office 14, 28, 52,
2021 Pontius Ave. 96, 115
Los Angeles, CA 90025
310-478-4775 t
310-478-4685 f

Wages Design Group 174
887 W. Marietta Street
Suite S-111
Atlanta, GA 30318
404-876-0874

Woodson Creative 126
2315 Paris Ave., SE
Grand Rapids, MI 49507
616-247-0090 t
616-247-8412 f

First published in the United States of America by:
Rockport Publishers, Inc.
33 Commercial Street
Gloucester, Massachusetts 01930-5089
Telephone: (978) 282-9590
Facsimile: (978) 283-2742
www.rockpub.com

ISBN 1-56496-770-0
10 9 8 7 6 5 4 3 2 1
Cover and Book Design: Stoltze Design
Cover image: Sundial mailer by Sagmeister Inc. (p. 12)
Printed in China.